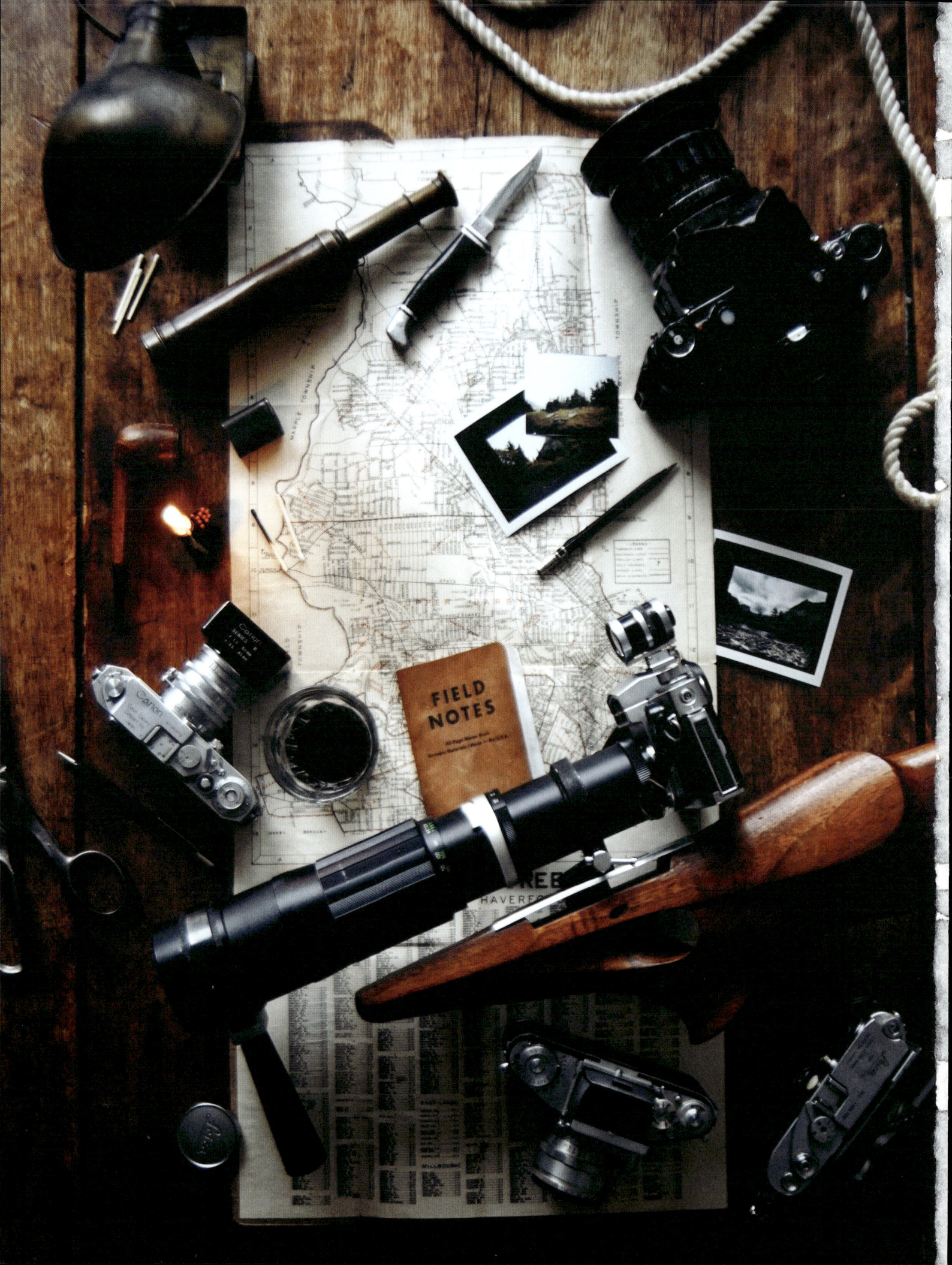

WILDSIDE

THE ENCHANTED LIFE OF HUNTERS AND GATHERERS

gestalten

VERDANT FOUNDATIONS: EXISTING, FORAGING, AND ROAMING WITHIN THE WILDERNESS

To entrust one's survival to the wisdom of nature is a brave, but nearly instinctual, desire. Sitting in synthetic structures, a restless energy builds and the rattle of the leaves speaks to our roots. The damp whispers of the forest air call to us to find comfort in their boughs and in their branches; in their soil and in their seed; in their waters and in their warmth. There are those souls among us who do not hesitate before answering nature's maternal beckoning. They embrace the challenge and, rather than view a lack of material comforts as an impediment, they see an opportunity to discover their surroundings—and perchance themselves—anew.

To some, sleeping under the stars enveloped in a blanket of fog and calm feels more like home than resting upon a feather mattress. Isaiah Ryan and Taylor Catherine, also known just as the Ryans, realized the blissfully unfettered nature of not having a physical address and called the open road home. The two freelance photographers finance their lifestyle through wedding shoots and adventure assignments whilst treading lightly when exploring surrounding landscapes. The Ryans have traded the soundtrack of the city, with its resounding car horns and the steady chattering of people, for the melodies of flora and fauna. Below tall trees and amidst the forests' shadows, the Ryans have found a home.

Family traditions guide those with a keen ear and an awakened mind further into the landscape to rediscover the ways of the old and craft traditional ways to suit the ever-evolving world of today. The very name of Lori McCarthy's Cod Sounds underscores the proclivity of our contemporary culture to walk away from the knowledge of our ancestors and the gifts of the land in favor of modern conveniences and familiar comforts. The cod sound is the air bladder that helps to keep a cod afloat throughout its aquatic life; the fisherman of Newfoundland and Labrador found nourishment in this simple and otherwise discarded part of the fish. The desirable flesh of the salt cod was sent out to the rest of the world to enjoy and experience. Along with the heads and the tongues of the cod, the fishermen lived from the monetary profit that fishing provided and from the pieces of their catches that no one else wished to consume. Cod Sounds offers culinary tours encouraging those outside of Lori's community to experience the treasure of sea sustainability, and the story of a people who possessed the imagination and will to find fuel in the discarded, the discounted, the detritus.

Finding ingredients in the bountiful wilderness of nature is a treasure hunt of viridescent and bronze hues; it is only logical that such vibrant colors hold equally as mesmerizing tastes and textures. The fragrances of

gathering sustains guests and provides year-round vitality, warmth, and flavor. The restaurant is honoring the past, living in the present, and remembering tomorrow, leaving some resources for the darker and quieter days of winter, of cyclical hibernation, of stillness.

Juniper Ridge combine native plant sources like tree trimmings or rich mushrooms with the memorable smells of exploring, such as the breeze over a glacier or the heat of the Mojave. For nature has a range of intoxicating scents that transform as the landscape shifts and as the air and soil adopt new notes and complexities. The craft lies in knowing both which tendrils and roots to gather and in understanding when to take them. A formula of infusion, genuine curiosity, and fresh harvesting tangibly captures the ephemeral scents of the outside world.

Picking elderberries in early autumn when their branches are heavy with ripe fruit: black skins beginning to split from a nimiety of luscious red juice. Spotting the large white blooms of the medlar tree that alert foragers to the presence of the golden tomato-sized fruits that taste of sweet citrus and soft stewed apples. There is a wisdom that comes from observing the land and the creatures that live from its earthy gifts. Christoph Keller has curated this wisdom and infuses his findings into fine fruit brandies: a contemporary alchemy. On Lake Constance, in an old mill, the Stählemühle distillery captures the tastes and aromas of outside endeavors.

Behind the doors of an exclusive restaurant, Magnus Nilsson synchronizes his menu with the rhythm of the seasons. The chef relies on ingredients that slowly ripen across acreage covering Northern Sweden. The bounty of summer and autumn months is harvested and stored in preparation for a long and dark winter. The intentional energy and time invested in hunting and

Leftover coffee, river water, and burgundy berry juice drip from Obi Kaufmann's paintbrush. The artist gathers images and transfers their innate beauty to paper in his growing collection of trail paintings. His essays give textual witness to the ecological sights in which he lives. Nature is both his home and his source of meditation and guidance. Obi's form of transcendentalism keeps him connected to the land and to himself, and this connective tissue resonates in his art. A meal may lay in wait in the bushes in the form of a rabbit or a young grouse, but a lesson lies in the process and a portrait in the scene. Obi speaks of the coyote that is present in his character, underlining the instinctual foundation of his chosen way of life.

To some it is about creating tradition as much as following it. Though young in years, Christian Watson finds himself rediscovering ancient wisdoms and new, but constant, truths. His illustration company interacts with the commercial worlds of big brands and shiny slogans, but his tiny pencil-drawn sketches have a raw authenticity that is captivating and intimate. A collection of seemingly simplistic tattoos lends his personal touch to his family's naval traditions. He is just as much a part of the story as his ancestors. Christian travels the open road: he is listening for the stories in the dust and he is telling the woods of his ponderings. We are connected to the forest, to the rivers, to the clouds.

Living in the wilderness is not always romantic. There is a gritty reality found in the damp recesses of a forest where fungus grows in moist soil that assaults the nostrils and coats the hand. Nature can be as loud as the din of a city, but the melody differs in its honesty and authenticity. That city din is created by us; nature waits for us to listen. There is more to take from nature than majestic panoramas; there is a supply of foods and flavors among the flora and fauna. The hunters and gatherers that live among those aural vibrations are collecting both elements for dinner and knowledge to keep in store for tomorrow.

Wildside captures the layers and rhythms of a life that does not yield to nature, but that coexists within its verdant realm. When the constructed comfort zone is left behind, we are asked to slow down and be a part of a journey much longer—and perchance richer—than our own timelines. To be human is to bear the mark of an adventurer, an explorer, a seeker. There is no specific skill set required: just the presence of a longing to embrace the wild both inside of us and surrounding us. ◆

THE JOY OF DISCOVERY
BY KYLIE TURLEY

Kylie Turley is an explorer. You are likely to find her—camera in hand—anywhere from Machu Picchu's ruins in Peru to the snowy slopes of Chamonix, France. Her heart, however, is firmly rooted in the American West, where her deep love of nature first blossomed. This very special location is the subject of many of her effervescent photos. The images brim with a sense of life, light, and color that reflects Kylie's spontaneous approach to living.

In regard to the driving force behind her photography, Kylie says, "I'm passionate about the people I meet and the places I go. This passion motivates me to look outside of myself and learn from the people I share this planet with. Not only that, but the earth itself can be incredibly demanding of our ability to learn from it, if only we are open to its lessons." ◆

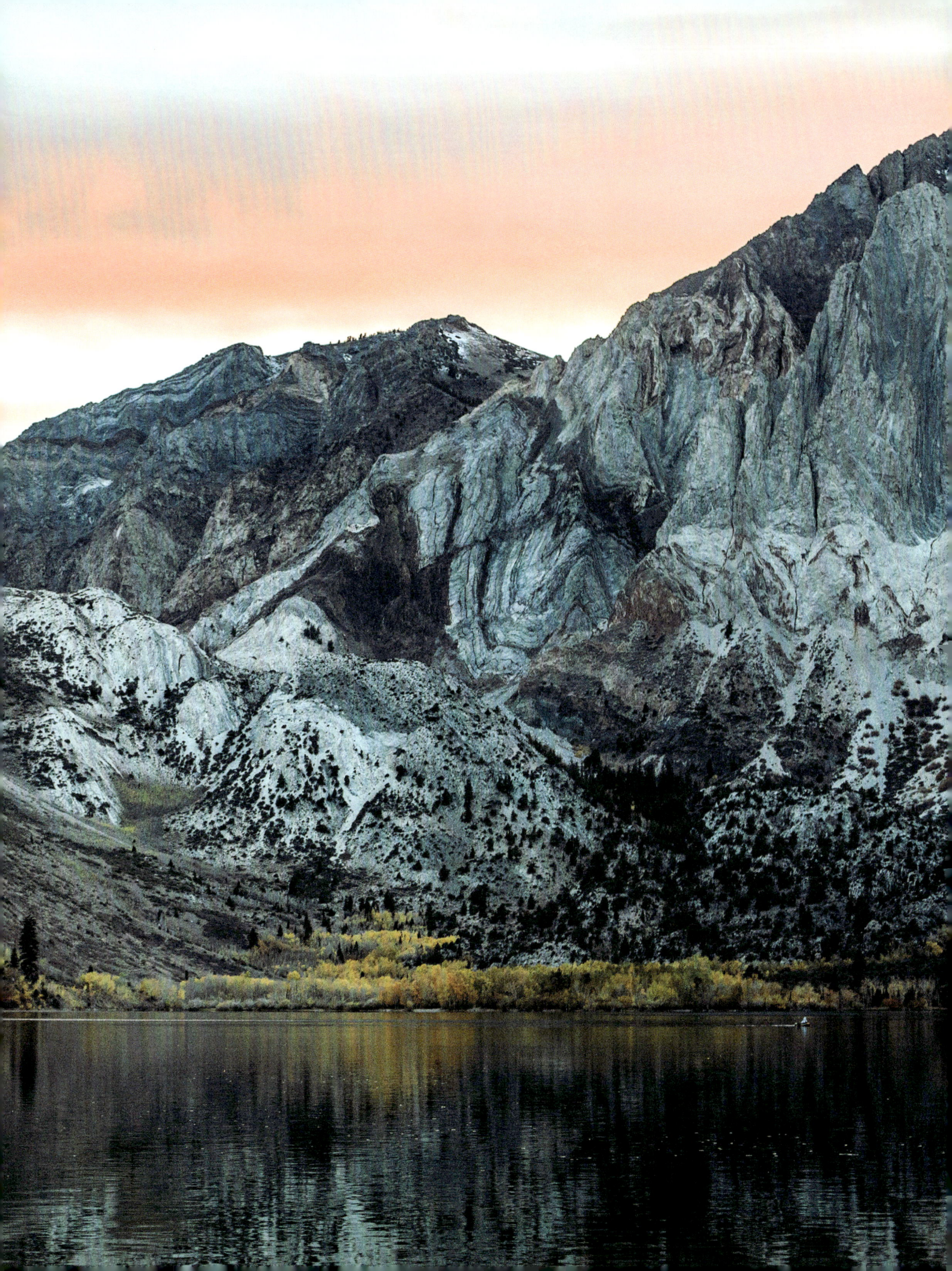

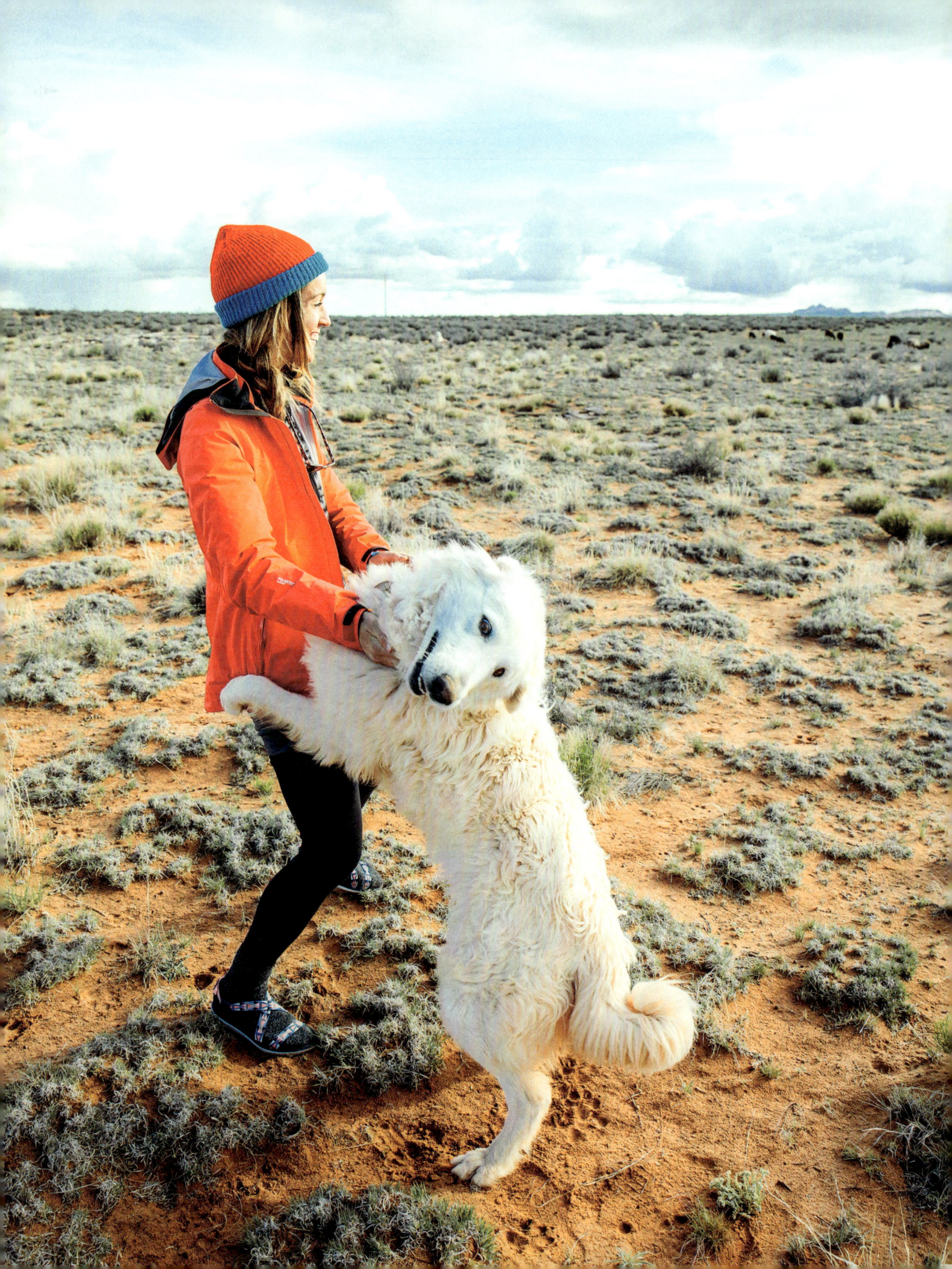

"The earth is growing, evolving, and moving—and so are the experiences we have with it."
KYLIE TURLEY

ROADSONGS

Married couple and modern hobos ISAIAH RYAN AND TAYLOR CATHERINE recount stories from their free-spirited life. They survive on their work as freelance photographers and travel wherever it takes them, connecting with nature as they go.

The Ryans— Isaiah and Taylor—are a husband and wife visual documentary team. They record and share their freewheeling life together—immersed in the wonders of the natural world and exploring new landscapes with soft and enquiring photographic eyes every week. Living out on the road, the stories they bring back and share with the world tell of simple explorations that resonate widely. They are tales of canyons and gulches, ice caves and deserts, skateboarding down frozen roads and treading gently while living close to the land. The Ryans survive as wedding and adventure photographers, going from job to job, exploring the wild lands they find themselves passing through. They travel light, ready at any given moment to up sticks and go wherever is needed. ›

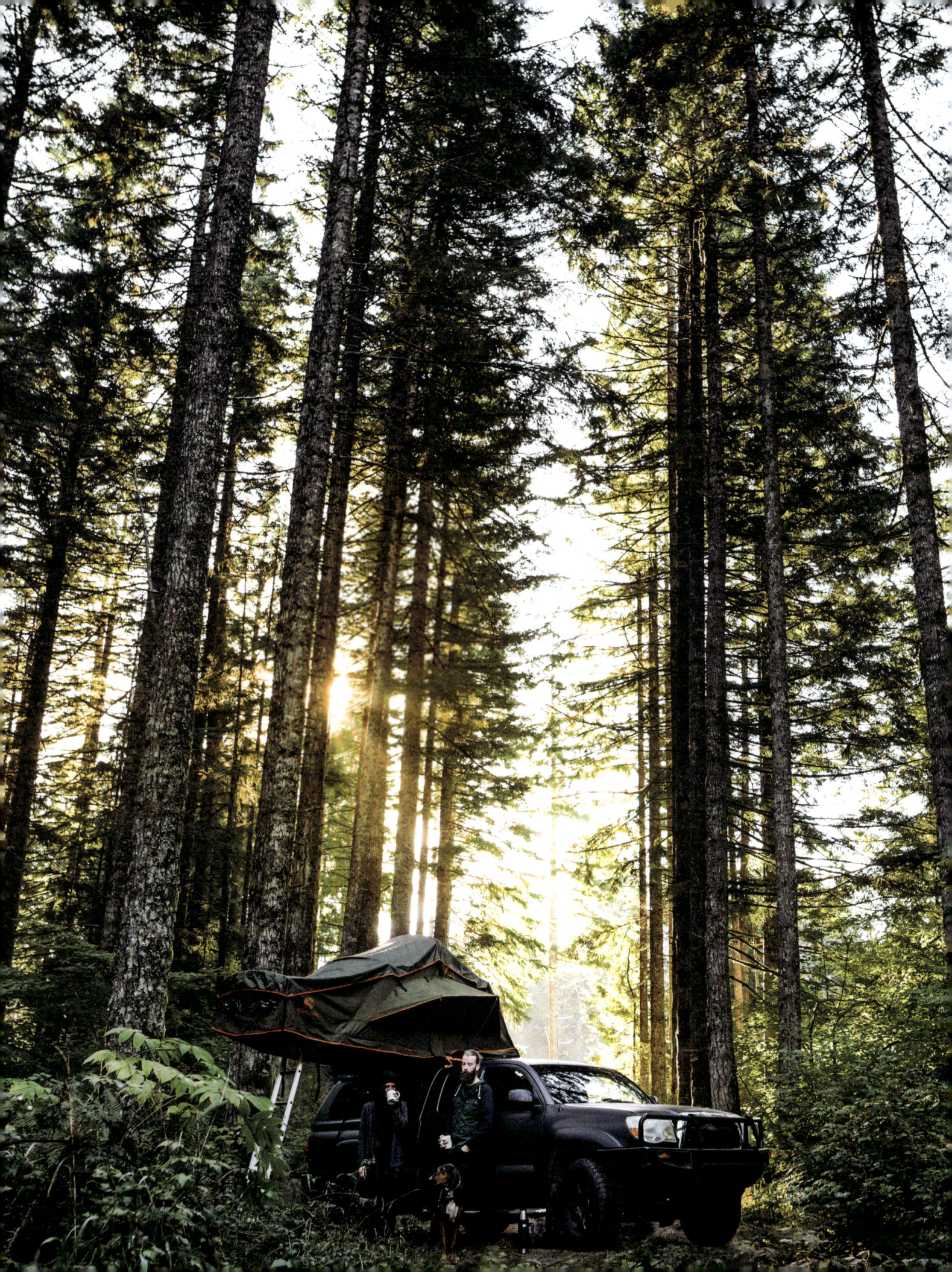

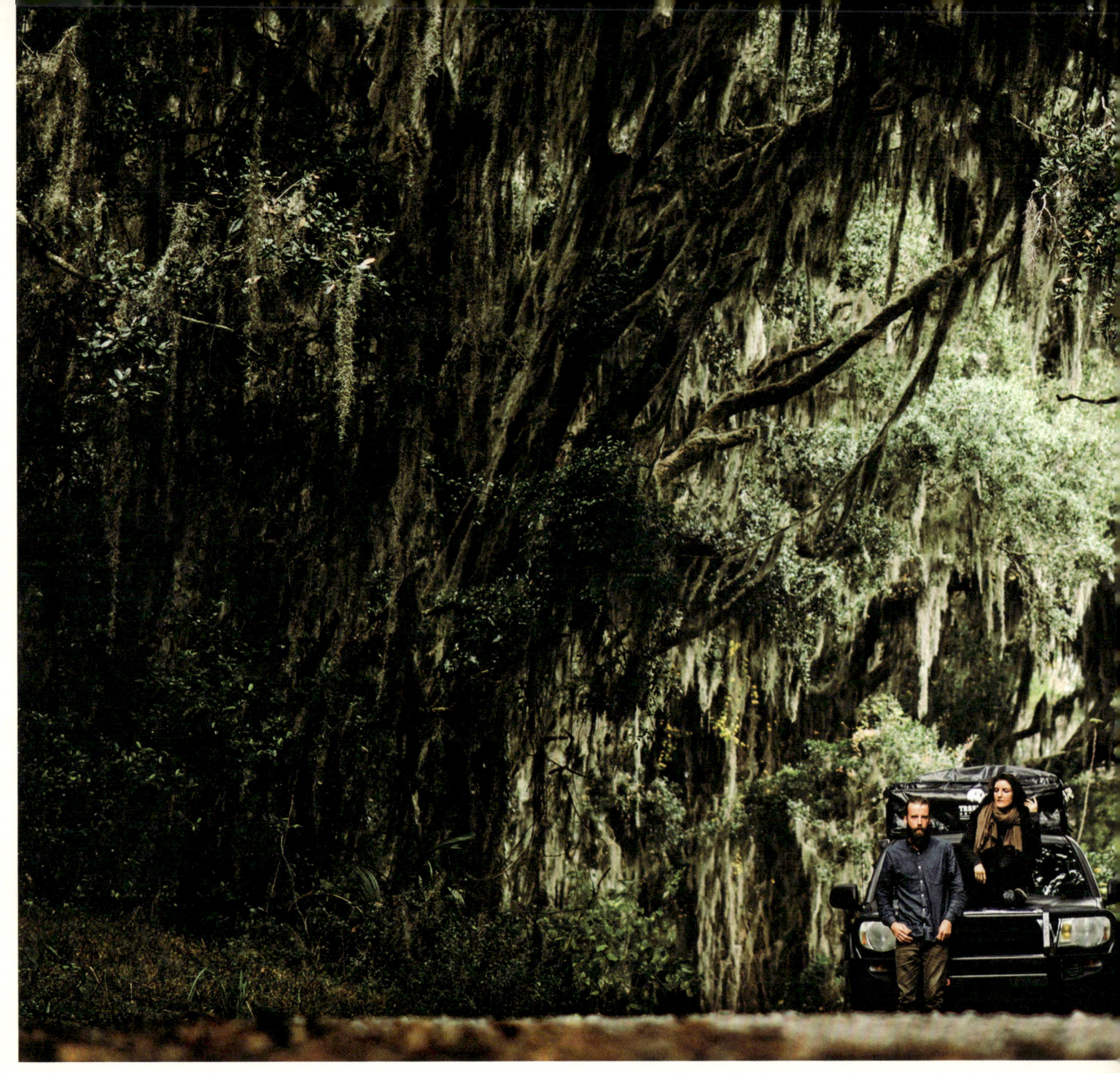

> "Instead of just being something fun
> to visit, nature has literally become our home—
> every morning to every night."
>
> **TAYLOR CATHERINE**

Despite both being nature-lovers before they met, the couple have chosen a path that has brought them much closer to America's vast natural environment. "Instead of just being something fun to visit," Taylor says, "nature has become our home—every morning to every night. So, physically, we are definitely closer." The journeys are incredibly stimulating for the couple and their photography, providing fresh forms of inspiration. "We start noticing more details," Isaiah responds, "we're more in tune with the way all of our senses interact with nature. The silence of the early mornings has such a unique, acute noise,

and we enjoy the transition of those noises into more obtuse noises later in the day, when the sun is up and more life is moving about."

As well as being an inspiration, spending so much time in the natural world also grounds the duo: "nature has already given us so much," they say, "and it's our choice to either enjoy what it offers or not. Spending time alone in nature has given us a sense of grounding in where we've come from and what we're a part of, what we are all a part of. So living on the road has also brought us closer to nature spiritually." It also firmly roots their appreciation for a life well lived: "Nature has always been a part of our lives together," the Ryans say, "we've both always appreciated it. But being able to constantly be around nature has deepened our appreciation for all of life. To us, nature means that there is something bigger, it's a constant reminder that we are all part of a greater narrative."

Isaiah identifies an emerging trend in America: advertisers exploiting nature as a consumable good. He feels that these individuals capture a visual aesthetic without any true care or appreciation for the subject matter. However, he sees a promising opportunity here: "overall," he says, "it looks like being in contact with the natural world is on the rise. So we hope that society's fondness for the look of nature cultivates society's care for its natural surroundings." ›

"We noticed we were sleeping in a tent more often than our bed ... Within one month, we sold everything we owned and prepped our home on wheels."
THE RYANS

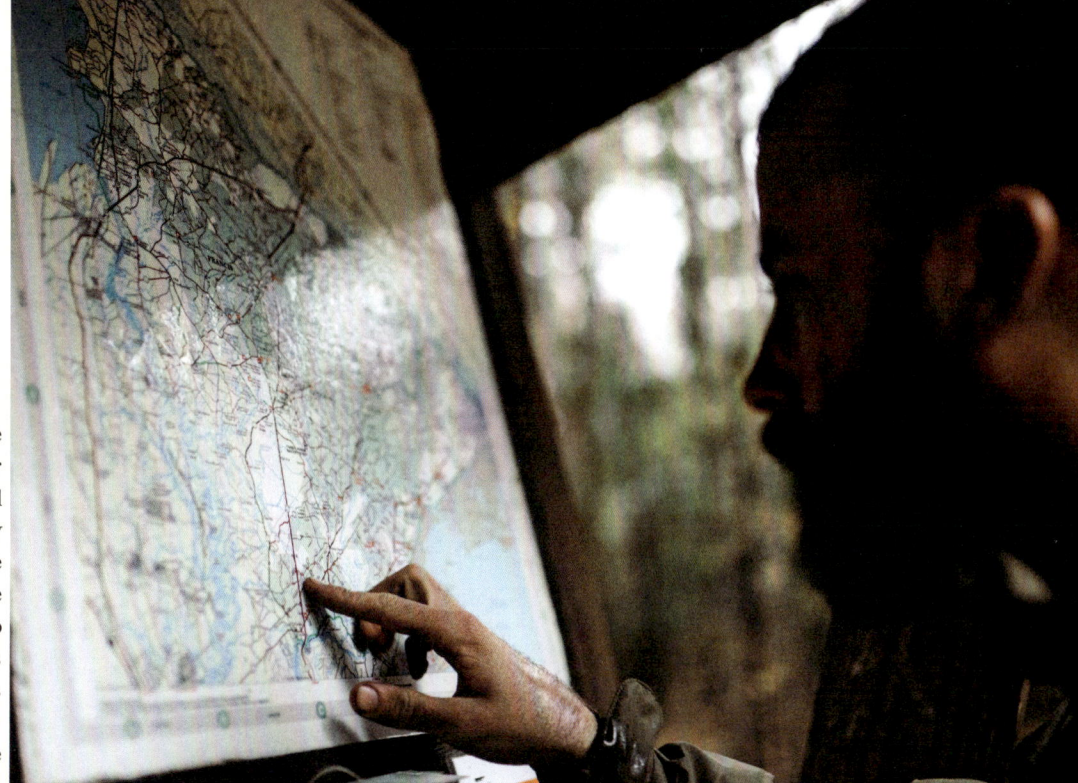

Living light, the Ryans roll through life accepting the reality of an uncertain future, ready to end up on the map wherever the wind (and their work) takes them. They are modern nomads, in other words, always in motion.

By relaying the stories of the road, the Ryans connect their audience with a fragile world that they might not normally see. The wild spaces the couple pass through, though they are visually documented, go back to their wildness once the Ryans have moved on. The photographs spread out like echoes, reminding their community and those further afield of the vital universe waiting at their feet. The couple had spent years tentatively discussing how they could get out on the road permanently, though they had no concept of whether they could turn their ideas into reality. It was a feeling that was born a long time ago in both of them. "The desire began in both of us before we had even met," they recount, "and just evolved into a mutual, distant future dream. Every month we'd be road tripping together for photography work. We would have to do the usual requesting time off work, and then returning back to the office. Eventually we both quit our office jobs on the same day and continued our full-time photography careers together. After a while we noticed we were sleeping in a tent more often than our bed. We made an impromptu decision that now was our time to do this. Within one month, we sold everything we owned and prepped our home on wheels. Our travels began."

In this way, the Ryans are completely open to whatever comes their way—their personal photographic stories are determined by where their paid work takes them. Modern hobos who are traveling light, the couple explain the extent of their chosen housing these days: "The shell of our home is a Toyota Tacoma with a camper shell and a rooftop tent (Treeline Outdoors) on top. Inside the camper shell, a talented friend of ours made a wooden drawer and bed system. The two drawers store everything we need and we can sleep on top if needed. Our living essentials include our generator (Goal Zero), powered by solar panels, which powers our fridge (ARB). We have a simple camp cooking set up with a propane stove."

The delight for the Ryans is in the ability to share their experiences together. Once their paths had crossed, they were united with a mutual dream—constant companions in a lifetime of adventure. The intrepid pair married five years after being introduced by a mutual friend in Southern California, and have not looked back to their office-bound days since they departed. Living free on the road is not without its challenges, however. "There are many luxuries you begin to miss when you've been used to living in your comfortable home, and then downsize to life on wheels," Isaiah says. ›

13

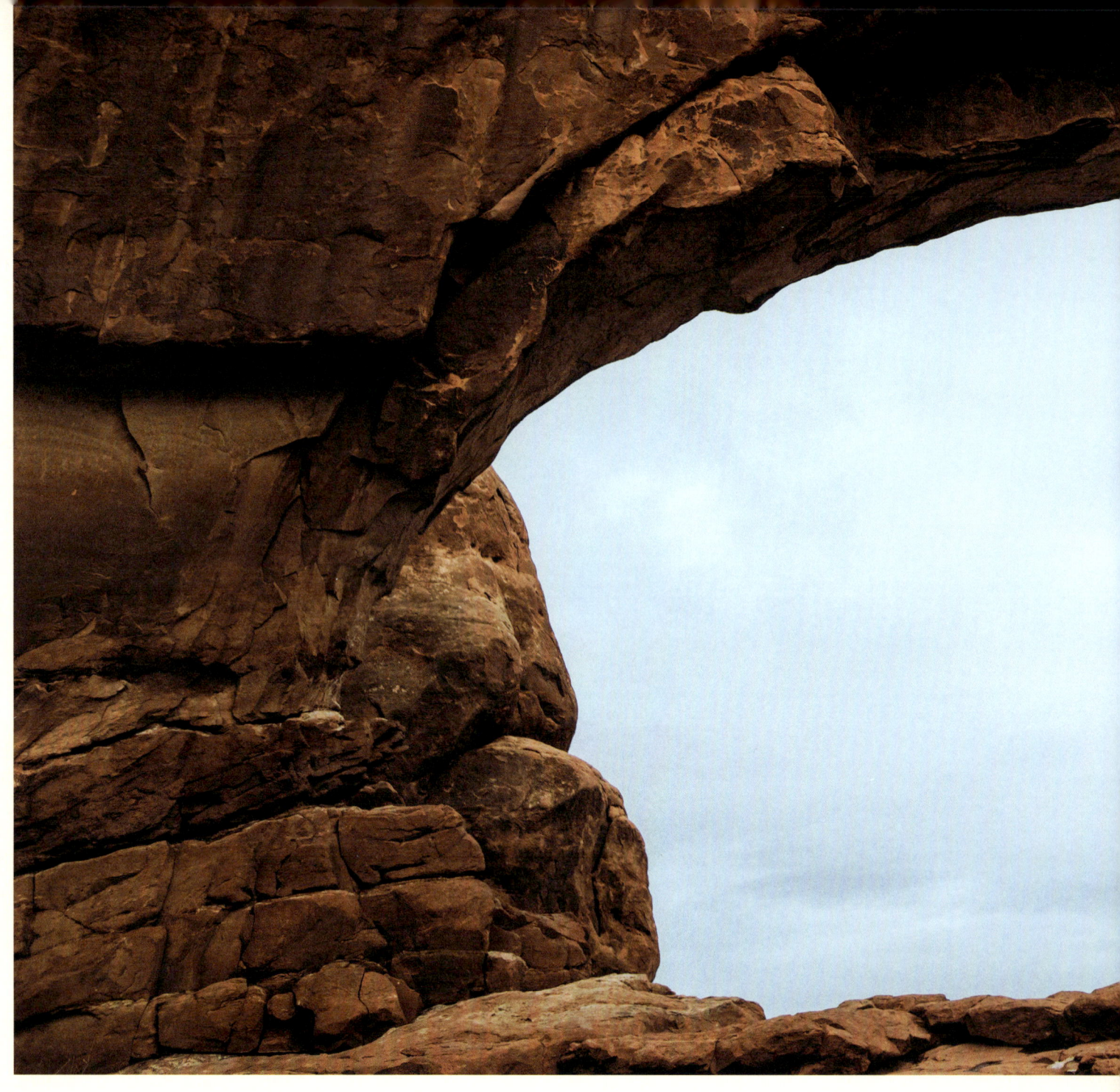

"Taylor specifically misses sliding down hallway floors with socks, so we traded that out with sliding on frozen lakes. And we traded in our comfortable warm showers with jumping in natural hot springs—though sometimes, at a pinch, we do use gym locker rooms."

The couple encounters all sorts of other people on the road, learning from their interactions and the simple kindness of strangers. It is a refreshing reminder of the human spirit. "There are many kind and gracious people in this world," the Ryans explain. "We've had complete strangers invite us to camp on their land, and we've had farmers gift us with baskets of fresh fruit for safe travels. We also learn little tips and tricks from others along the way."

Their rules for the road are as follows: "Common sense and discernment comes in handy. Learning how to interact safely with our world is very important. There are many frightening accidents that can happen if one doesn't know how to enjoy nature safely. Making the right choices about where to explore and learning how to treat wild animals are musts."

Living this way means that the Ryans have to accept whatever comes up, and, going further still, that they do not know what their immediate future looks like. It is a situation that would not suit everyone, but both seem incredibly comfortable with their circumstances. "We are both creatures of change. We seek out diversity—and can take equal pleasure in the vastness of

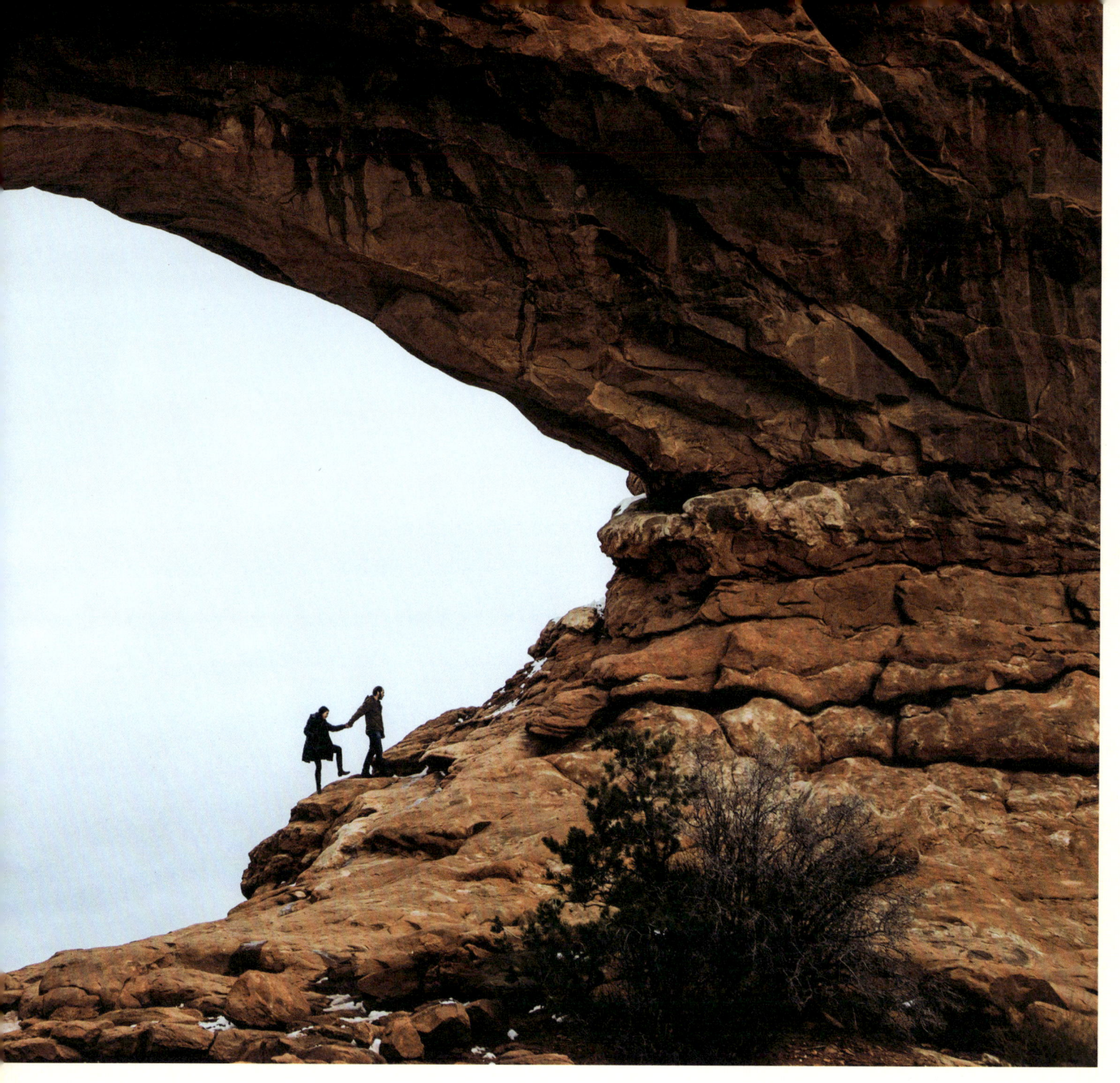

"Nature means to us that there is
something bigger, it's a constant reminder that
we are all part of a greater narrative."

THE RYANS

the open desert and the denseness of a lush forest. Growing up in Southern California, the main nature we knew was the beach, so we strive to be up on mountain tops or lost in dry canyons."

The Ryans live without fear, delighted with what they have found and with the life that their skills afford them. "This was a grand dream of ours," they say, "and it still blows us away that we have followed it much sooner than we had anticipated. We live our life day by day, and enjoy the spontaneity that comes with it, while still building bigger dreams for our future." Long may it last. ◆

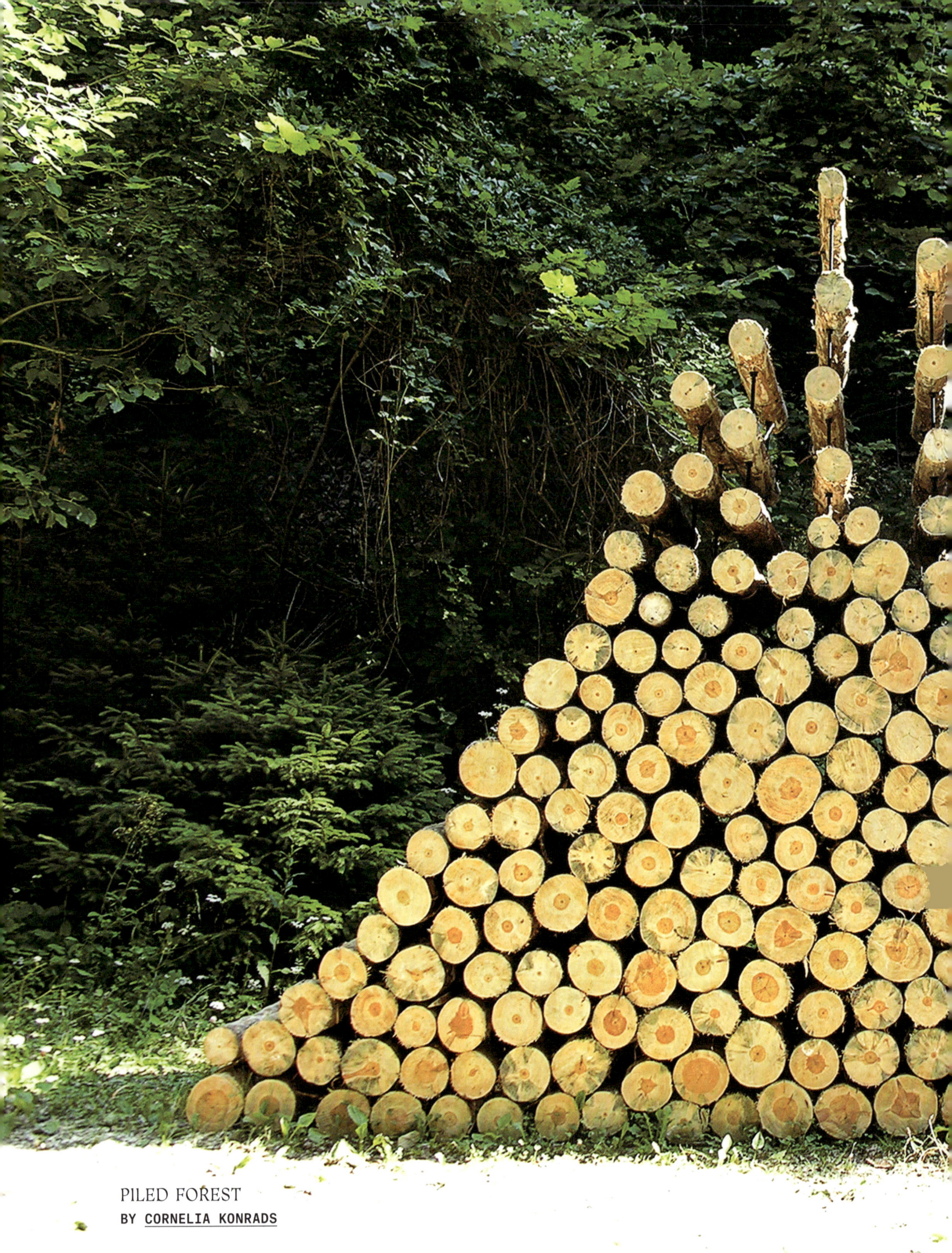

PILED FOREST
BY CORNELIA KONRADS

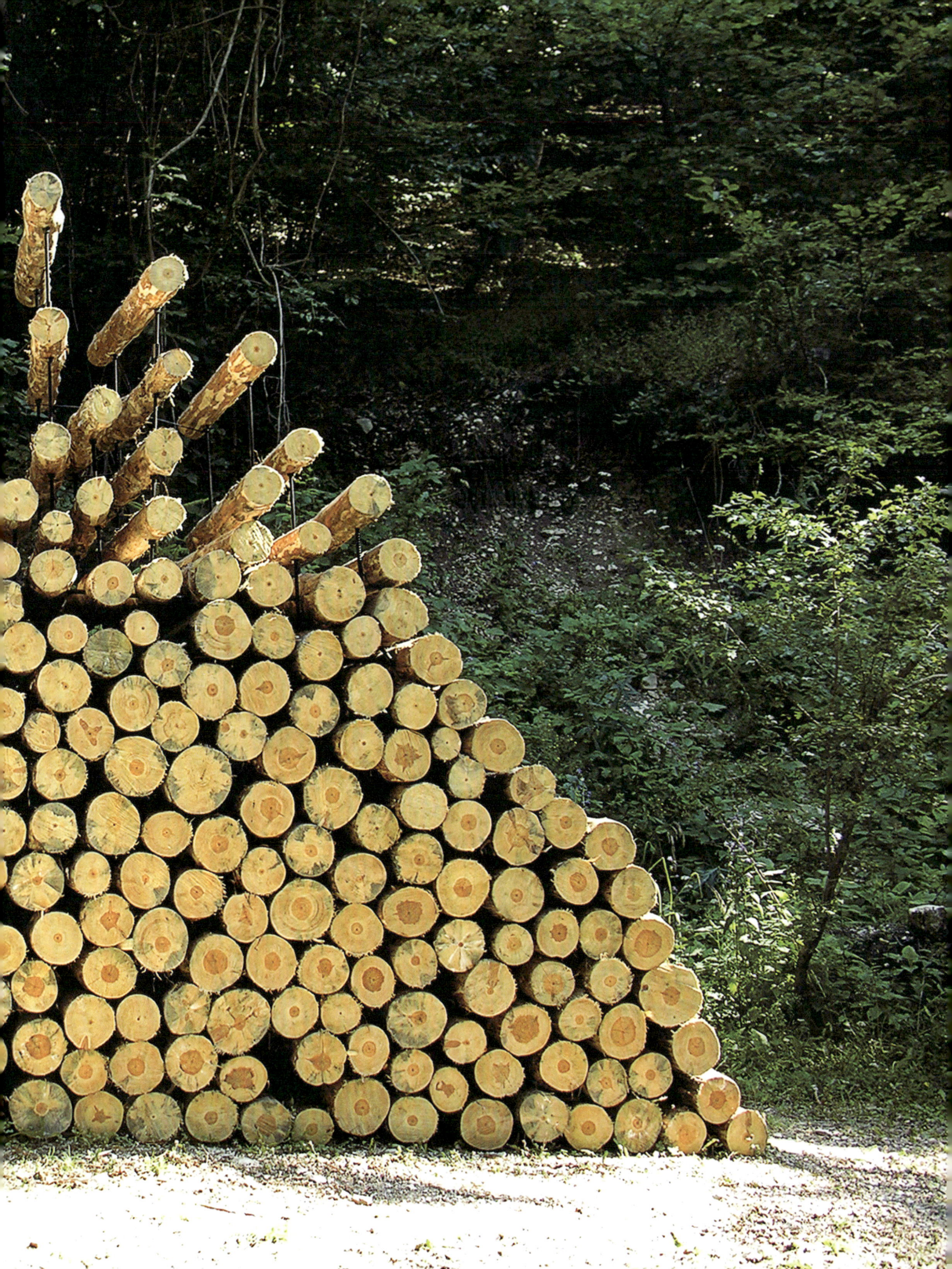

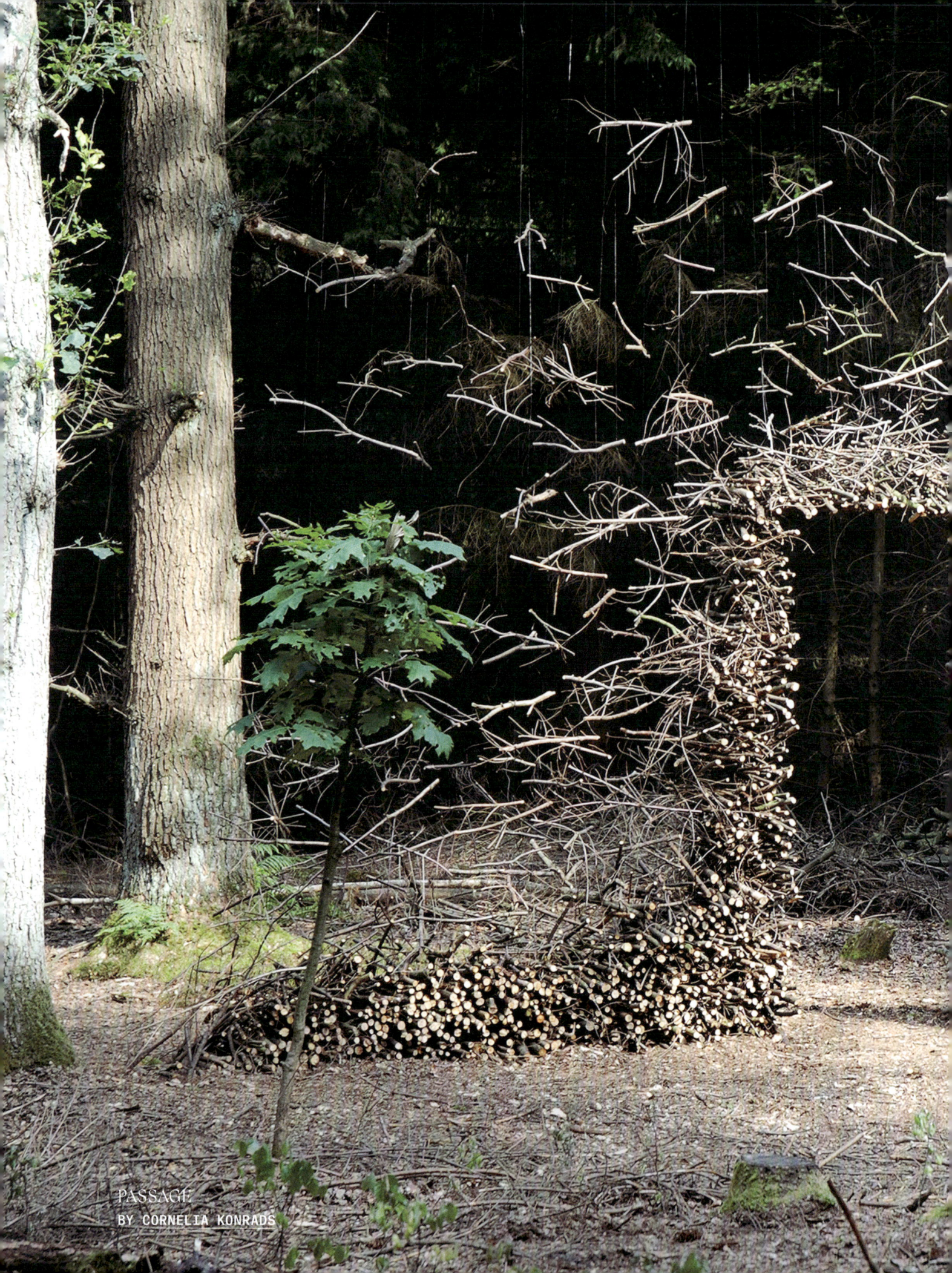

PASSAGE
BY CORNELIA KONRADS

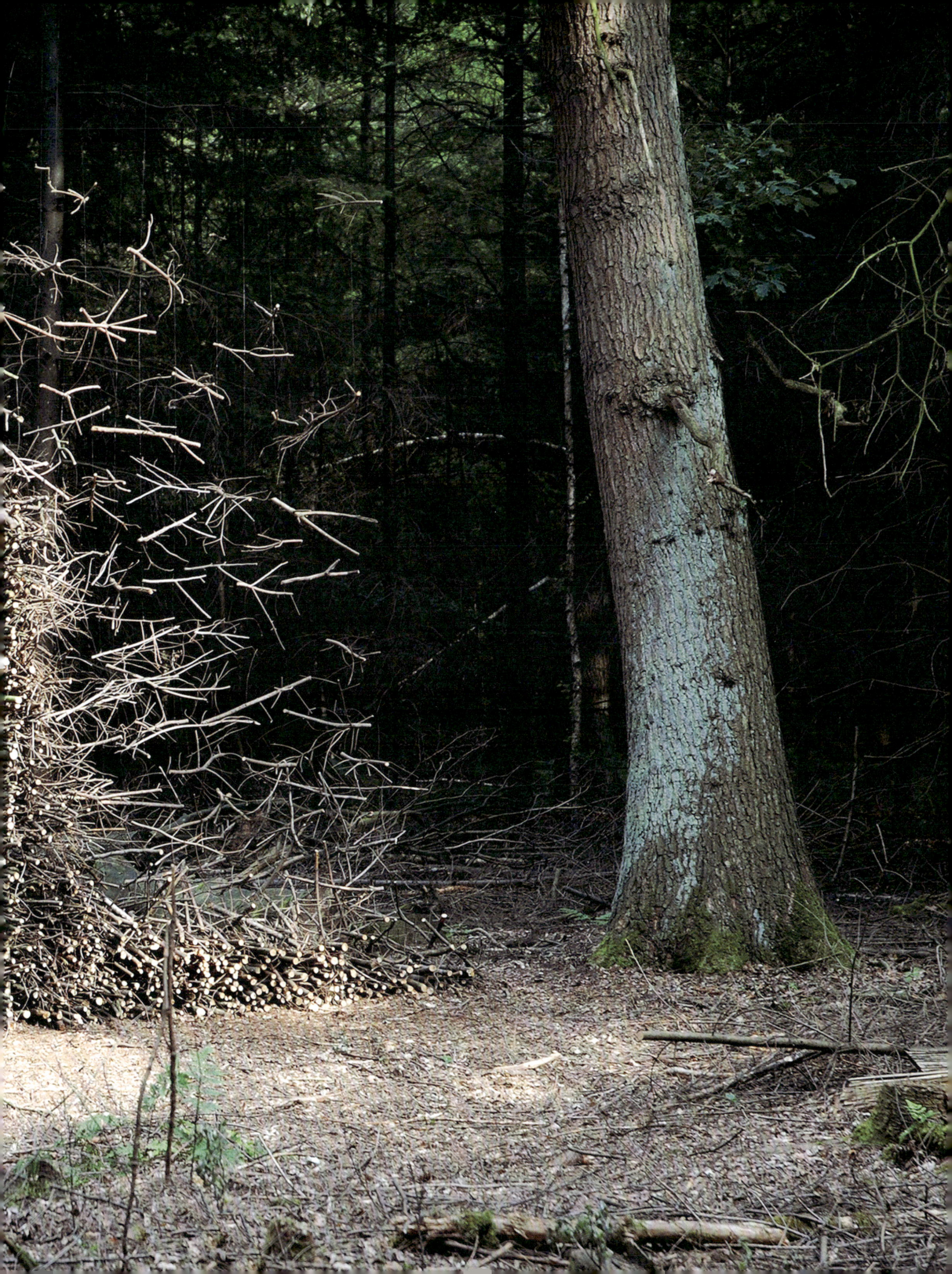

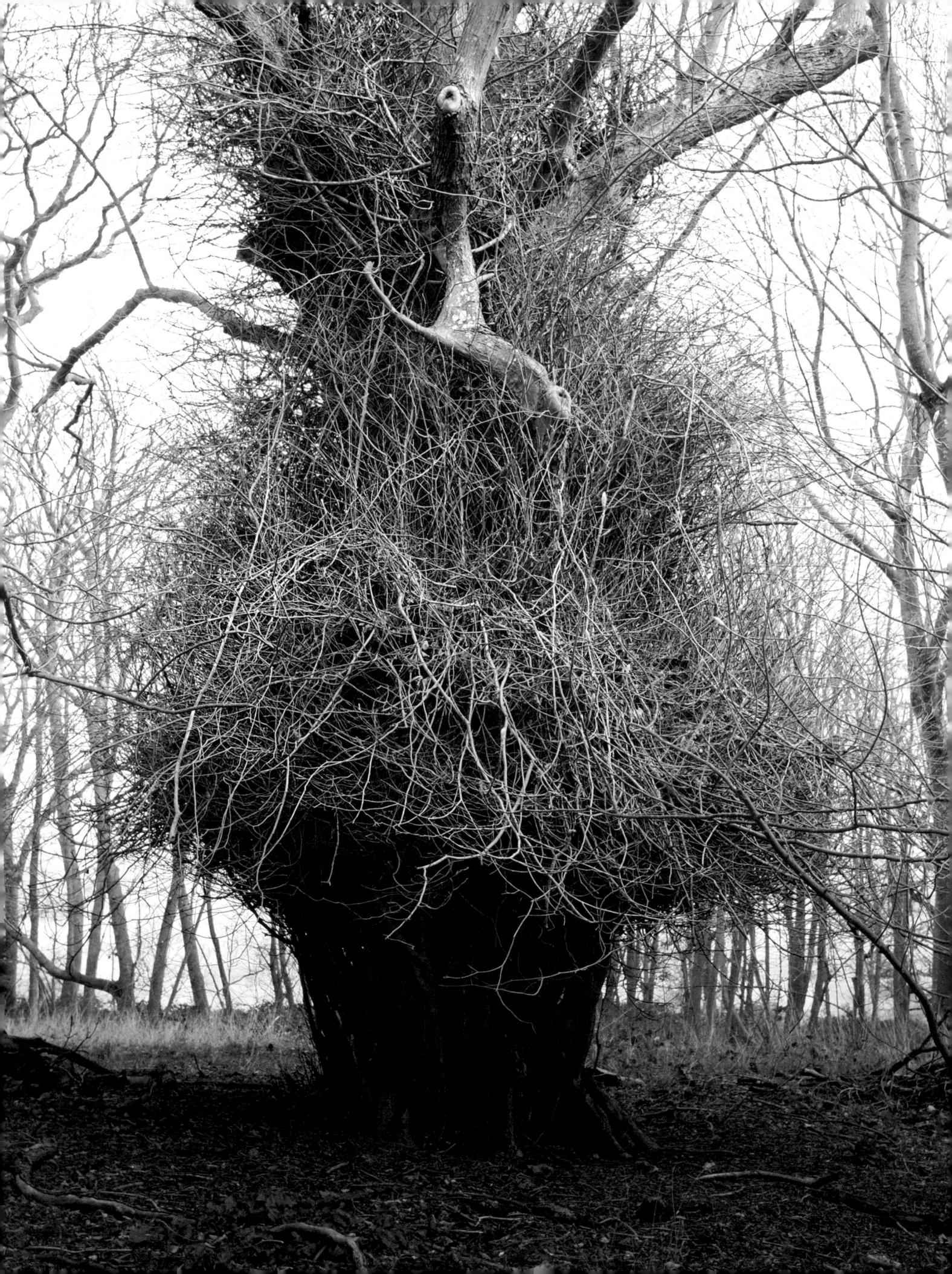

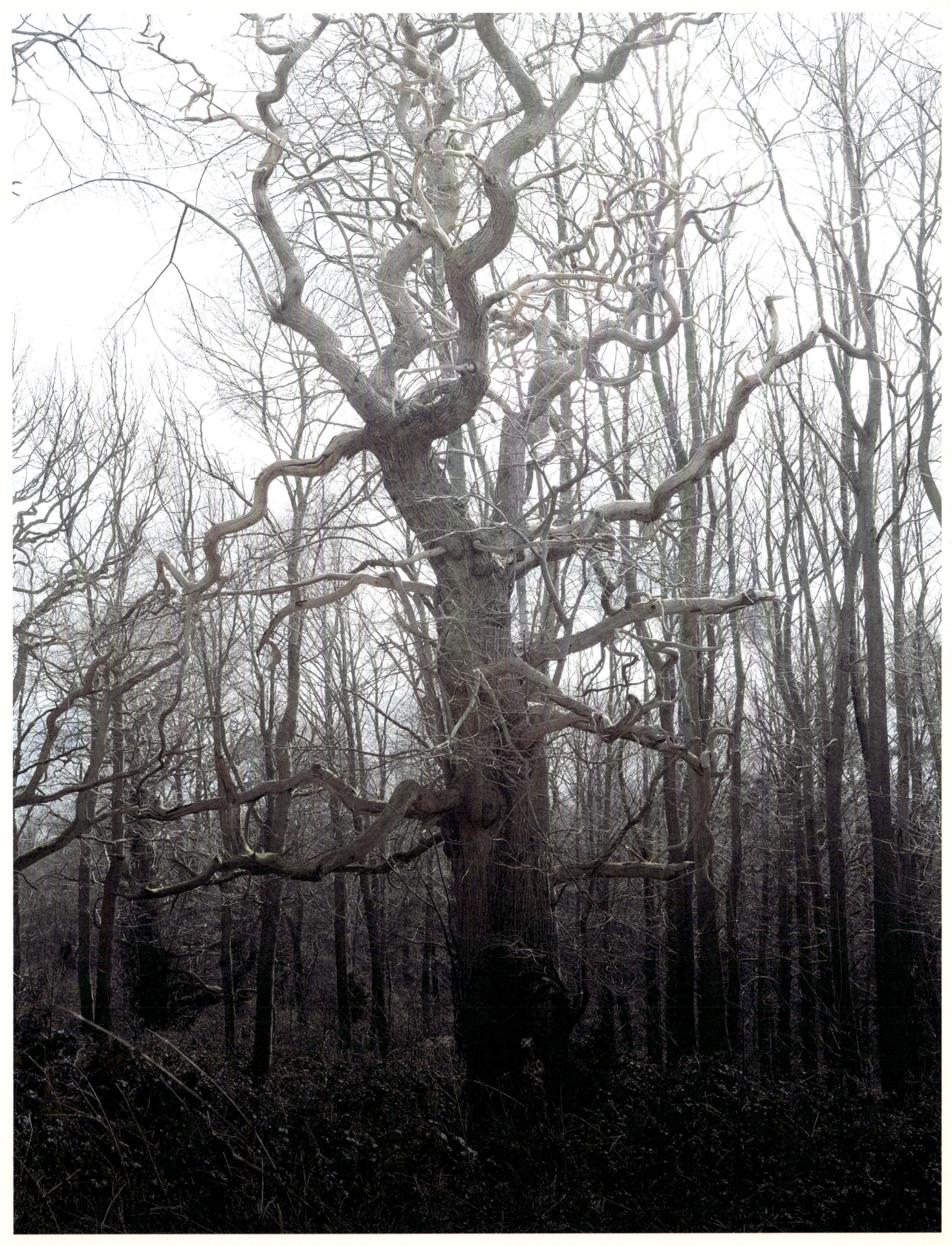

WYTHAM WOODS BY JANNE SAVÓN

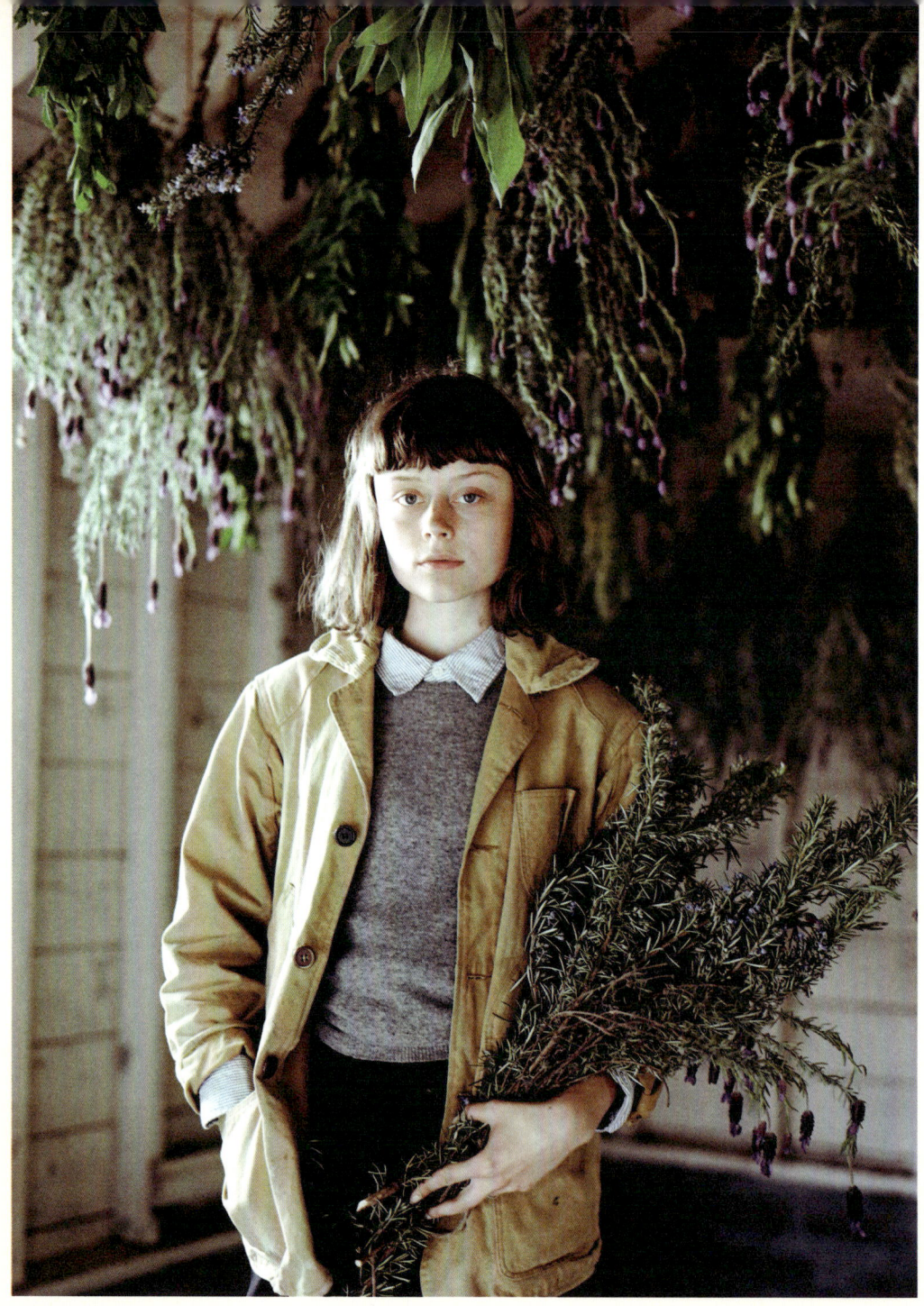

PRESERVING HERBS IN PORTLAND
BY PARKER FITZGERALD, JAMES FITZGERALD

Parker Fitzgerald and Amy Merrick live on opposite coasts of the United States: he is based in Portland, Oregon, on the west coast, and she dwells in New York on the east. But the two talented artists and friends did not let distance stand in their way for this gorgeous collaborative project about herb drying for *Kinfolk* magazine. In a small garage in Portland, illuminated by slivers of silvery window light, Parker's lens and Amy's impeccable herbal arrangements unite in a swirl of shadowy purples and minty greens. Parker's use of natural light, augmented by Amy's tasteful styling, conjures up a timeless vision of a woman and her relationship with her garden—a place where quiet moments are savored and the scent of lavender lingers in the air. ◆

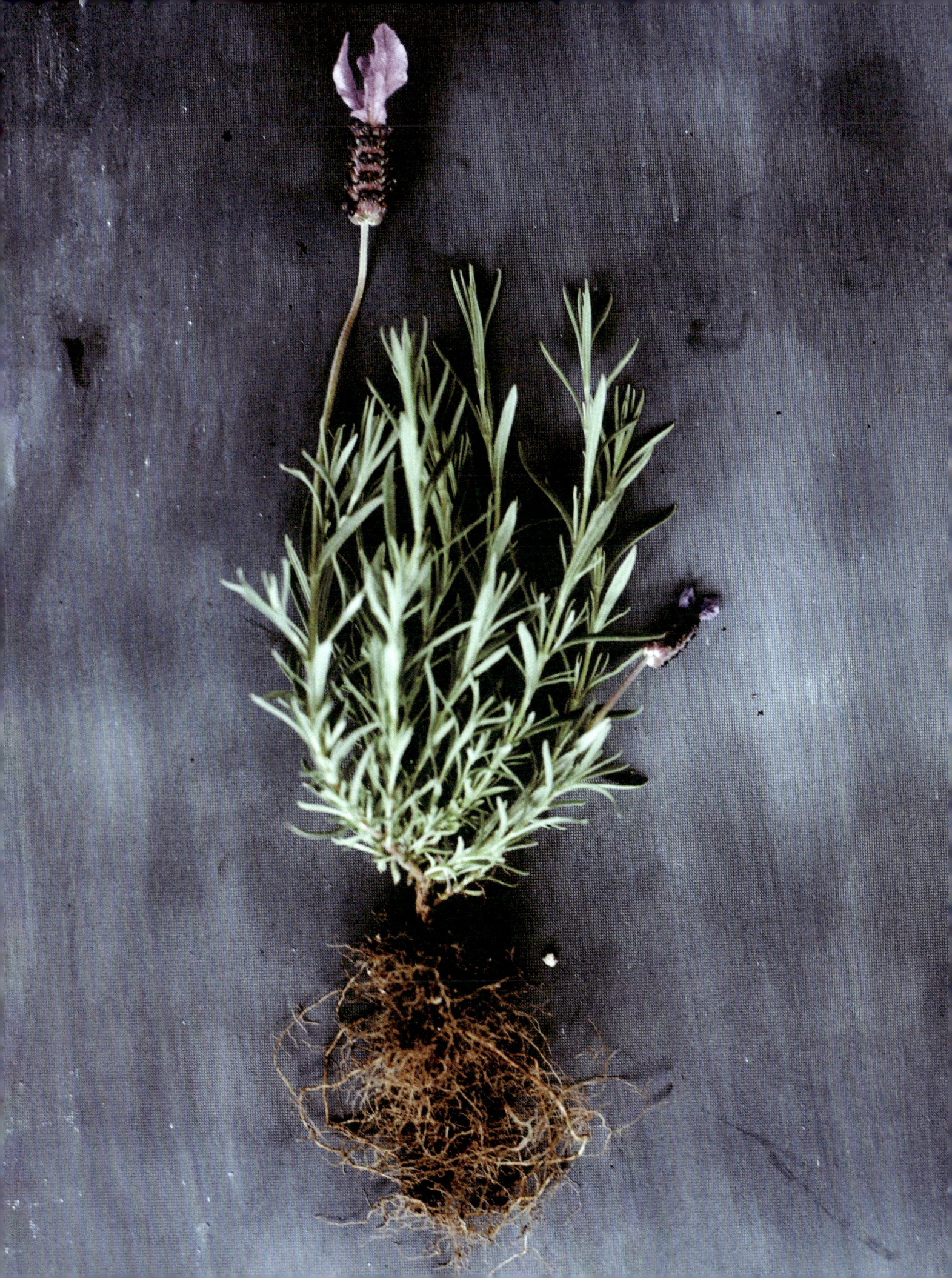

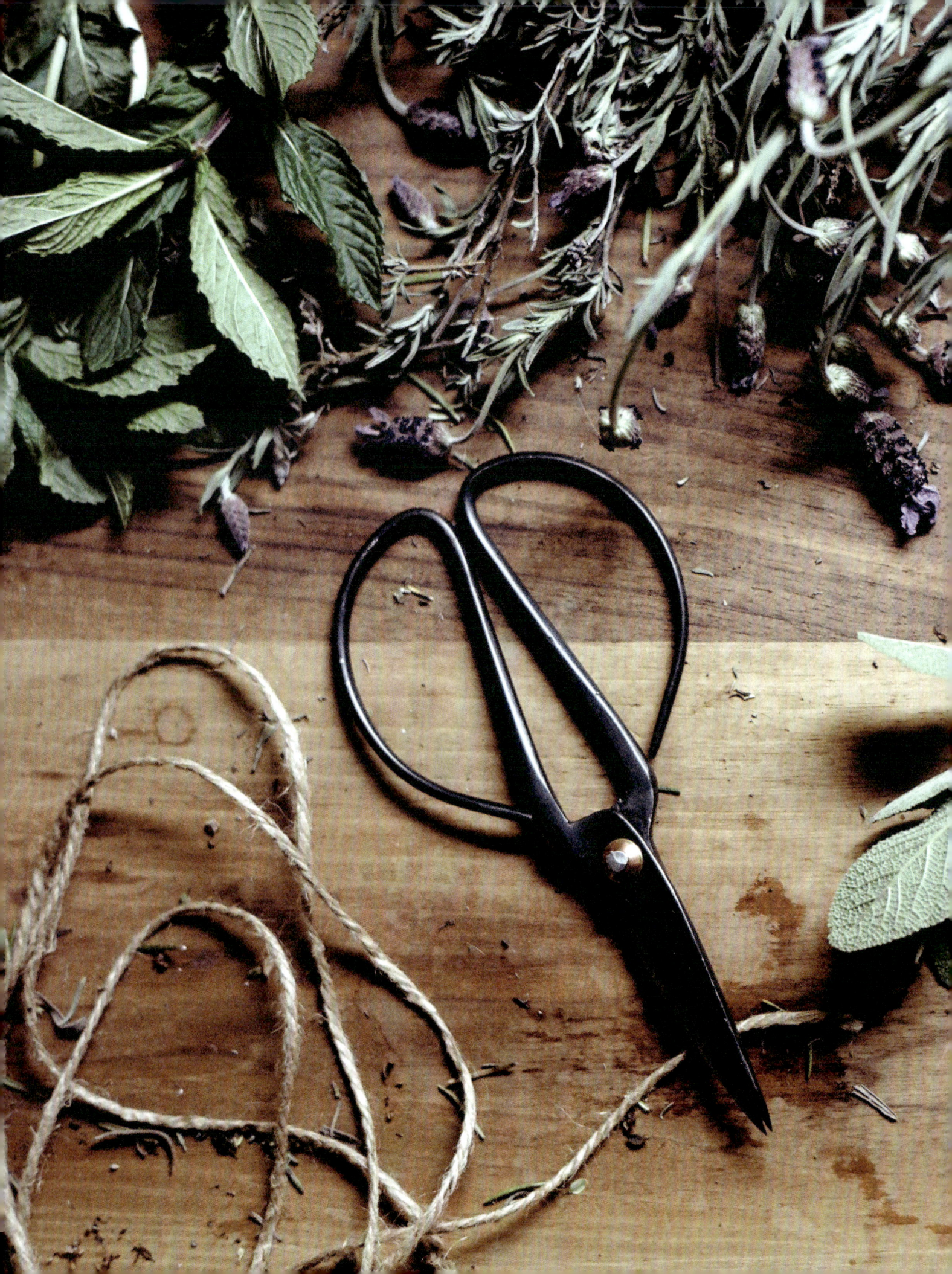

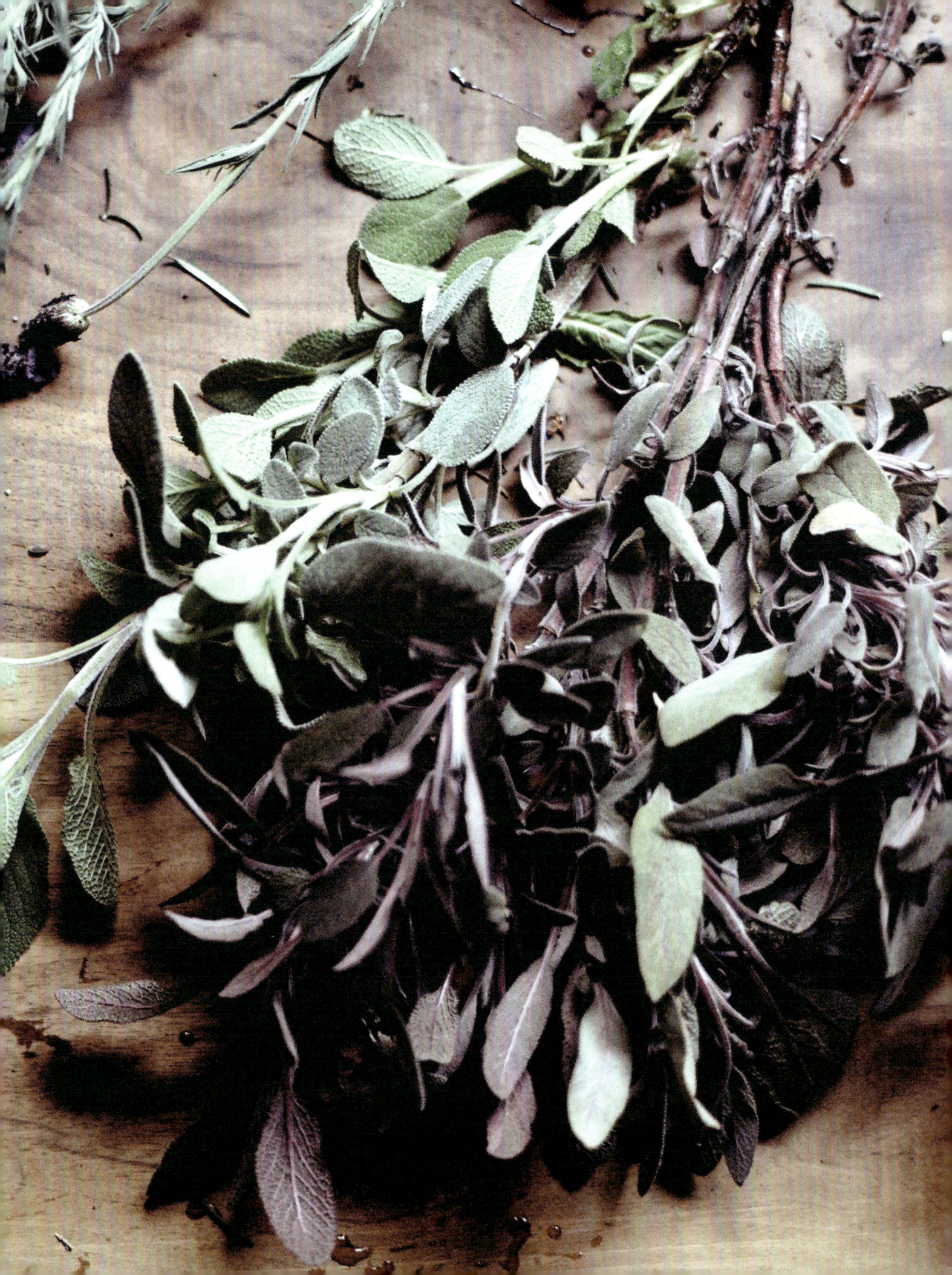

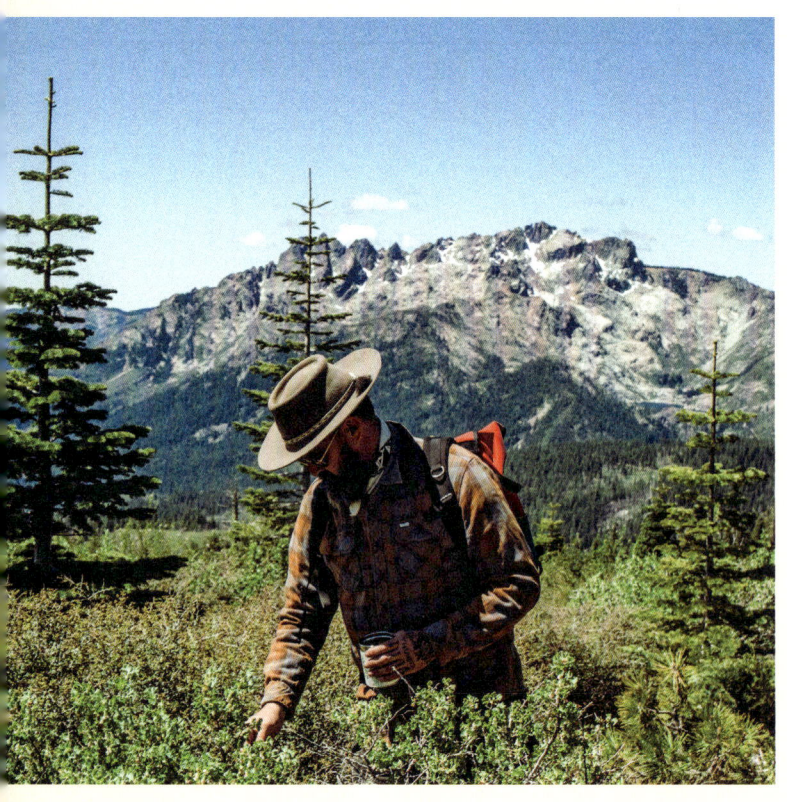

EXTRACTING FRAGRANCES FROM THE WILDERNESS

One precious scent at a time, JUNIPER RIDGE captures aromatic snapshots of the great outdoors.

One of the most vivid sensory experiences encountered in the wild is smell. Like most senses, many modern humans have shut themselves off. The American wilderness, in particular, is an olfactory delight. Around the campfire, out on the road, and on the trail, Juniper Ridge harvests wild plants and distills natural fragrances, making a range of limited-edition perfumes and soaps. The very nature of the process (labor-intensive, methodical, small-scale) is highly disruptive to the mass-market perfume industry. But for founder Hall Newbegin, it all starts with a helpless love for the natural world. Everything that Juniper Ridge has become stems from this heartfelt passion.

Juniper Ridge endeavors to catch the ephemeral, transient scents of the great outdoors, places that ›

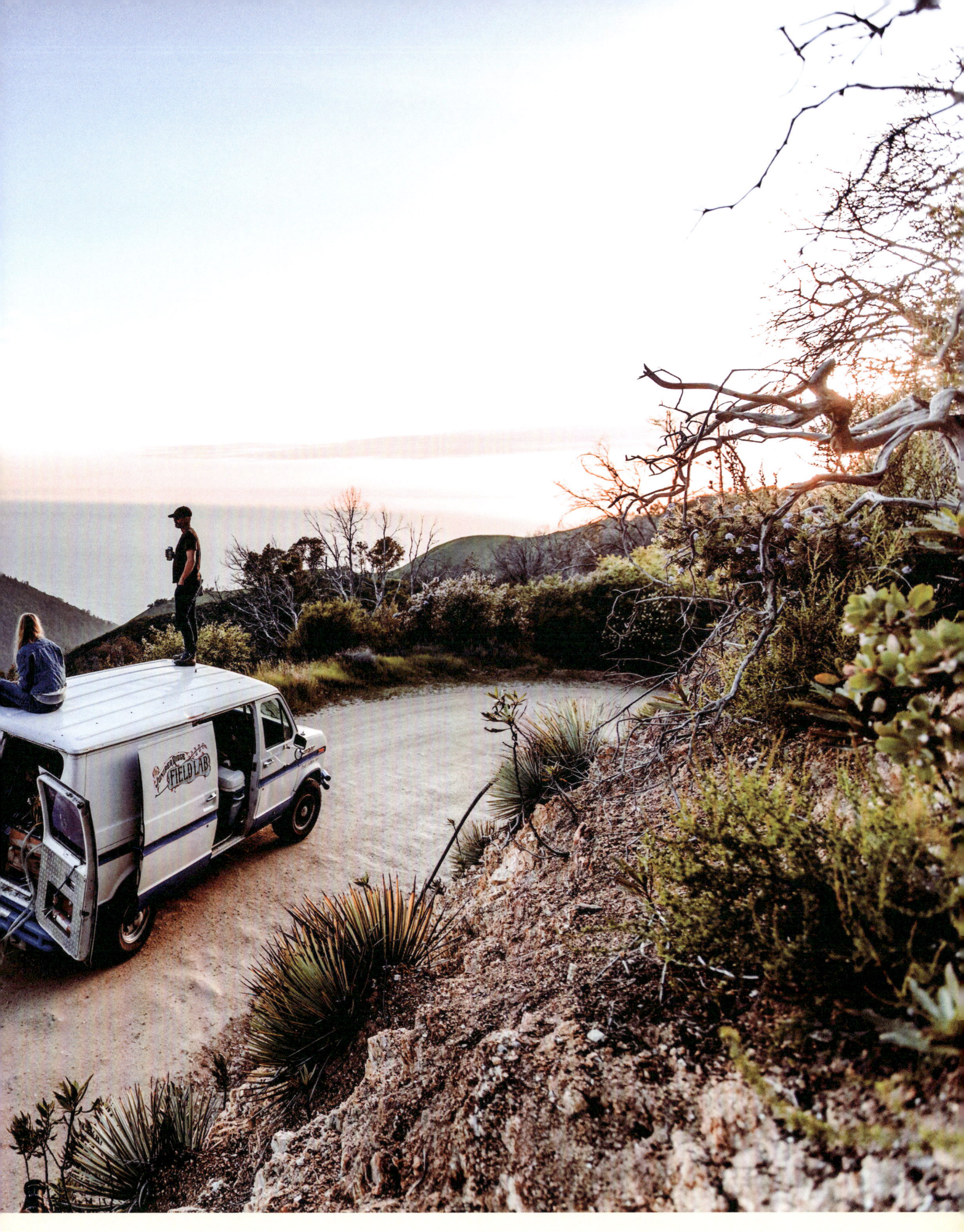

"I think everyone needs to be part of something bigger than themselves."
HALL NEWBEGIN, JUNIPER RIDGE

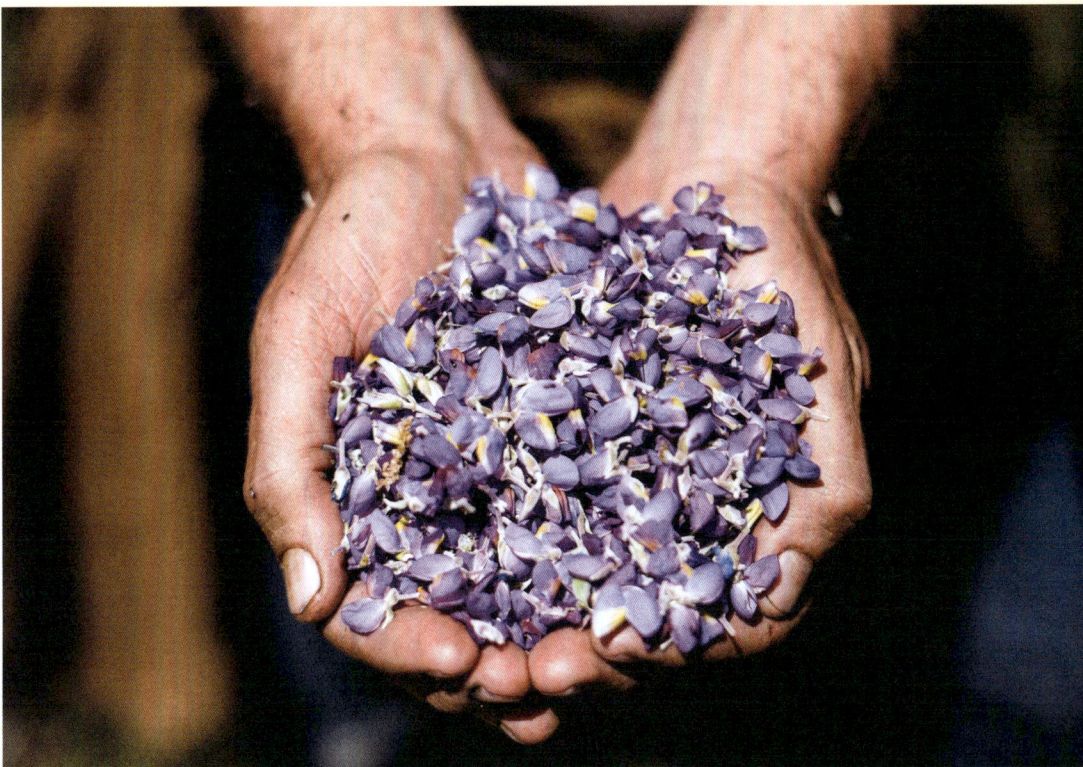

Trekking through the wilderness is like walking through an open treasure trove. Extracting the best from nature means tapping into one's primordial senses, and being sensitive to one's natural surroundings.

change day by day. Hall describes these "aromatic snapshots" as a way to capture temporary beauty. The team aim to transport their customers straight to the wild places that inspired the scent, be it a glacier near Mt. Hood, a cabin in the Sierra Nevada, or a fire in the Mojave Desert. Tradition forms a major part of the process, with techniques such as steam-distillation, tincturing, and enfleurage virtually lost in the modern world. Most industrially-made perfumes no longer use real ingredients due to the widespread availability of cheap, synthesized fragrances.

For Hall Newbegin, the relationship goes much deeper than simply wanting to be outside. He credits nature with saving him. "I have a ravenous, crazy, compulsive thing about nature," Hall says. "My mind races with anxiety, just like anyone else's. When you see pictures of me crawling around smelling dirt, it's a lifelong coping-mechanism that helps me find my center and get some perspective." Things did not come easy, with heavy depression and confusion about life weighing him down. "I think everyone needs to be part of something bigger than themselves," he confirms, "finding a connection with nature, something so grand and wild and outside of myself, really saved me." Whilst out on the trail collecting ingredients for Juniper Ridge products, Hall finds comfort in the natural world.

It is a familiar refrain for many nature lovers of different disciplines: "Out there," Hall says, "it all goes quiet. Suddenly, I'm just there, waking up from a nap in a wildflower meadow to bees flying overhead, the blue sky, the massive glaciers, and that beautiful big mountain sitting right in front of me. I find deep connection there." This was the catalyst for starting Juniper Ridge and it is the motivating factor that drives him forward. If Hall can provide a deep emotional response for the people that his products reach, he will have achieved his goal.

"Humans are animals," he says, "and we truly interact with nature through our noses." Smell, for Hall, is the most vital sense.

That very sense of smell could be vital in connecting people with nature. Hall sees that smell itself grounds the senses. "Our sense of smell is the quickest way to connect to the present moment," he says. "It doesn't matter if you're on the eightieth floor of a skyscraper in New York City or you're deep in the backcountry of the Sierra Nevada range; engaging your sense of smell grounds you in the present, in the nature that surrounds you." This purpose underlies everything that Hall and Juniper Ridge do.

As well as running a successful commercial enterprise, Hall is deeply motivated to opening people's eyes to what the natural world has to offer. He gets really animated when describing how taking people out on hikes affects them. "The most rewarding thing to me is watching people tap into those animal senses," he says, "I love leading groups through these ›

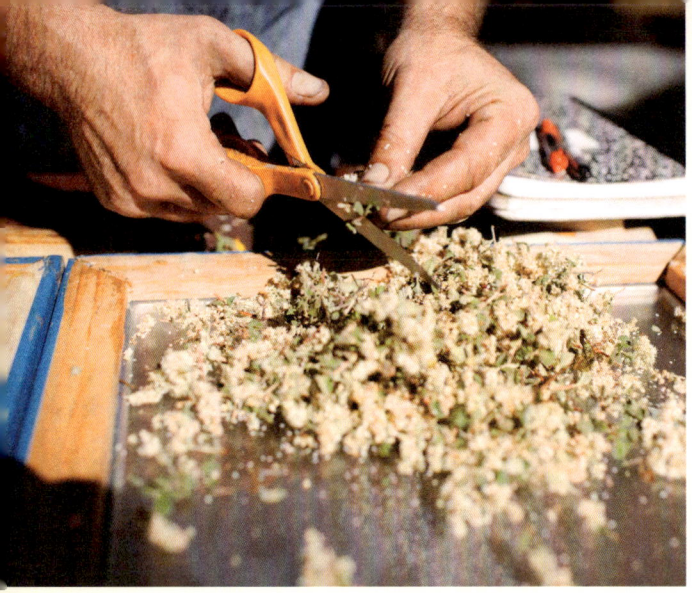

A physical connection to the natural world triggers a deep emotional response in Hall Newbegin. Juniper Ridge's method of harvesting and preserving wild plants goes back hundreds of years, which heavily relies on intuition.

"The most rewarding thing to me is watching people tap into those animal senses."

HALL NEWBEGIN, JUNIPER RIDGE

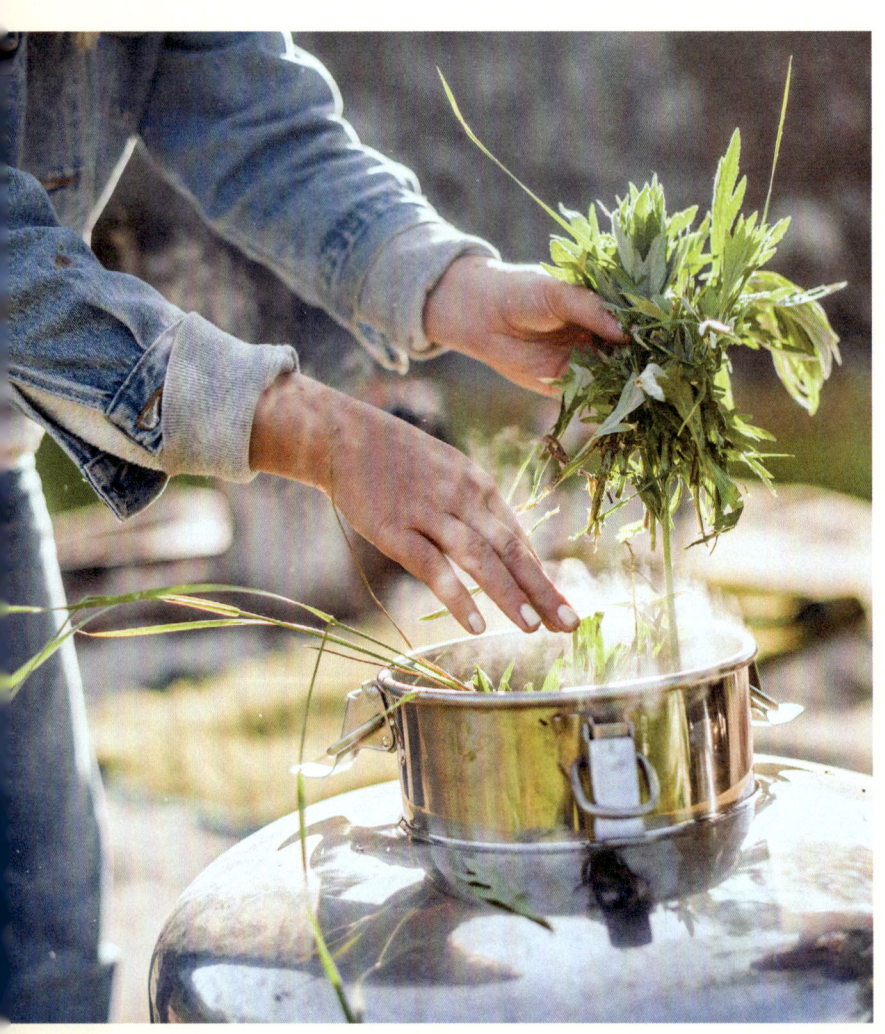

places that have meant so much to me. That's my purpose." In these circumstances, Hall stumbles across the ingredients that make up his perfumes; every harvest is a unique experience and each product changes from day to day. As well as capturing the plants themselves, Hall tries to catch the transition of the seasons and the environment among which the plant grew. He will make limited editions, under 200 bottles, which sell out fast.

There is usually a vague idea about what Hall wishes to harvest. A typical Juniper

Ridge trip starts with a shortlist of plants, though this can change. Being relaxed and open to the present and the nuances of the fertile ground leads to the best possible perfumes. Although the process is ancient ("essentially the same way French perfumers worked over three hundred years ago,") the team are producing more and more sophisticated scents. When ingredients are found, they are harvested in a sustainable way that only benefits the landscape. "Neither the trees nor the ecosystem are harmed by this type of careful pruning," Hall confirms. "Everything we do is done with permission and harvested sustainably."

The ability to be flexible is a vital part of the success. It is a complex process that differs every single time. "We don't make our fragrances the same way every time," Hall says, "standard recipes and formulations are boring to me. Places change all the time, not just from season to season. Each harvest is a unique experience and our products should reflect that." He speaks of a particular scent they are formulating, a trial perfume inspired by Mt. Hood and its giant glaciers. What they are trying to create is "a love song in a bottle" that perfectly encapsulates the smell and feel of the end of summer.

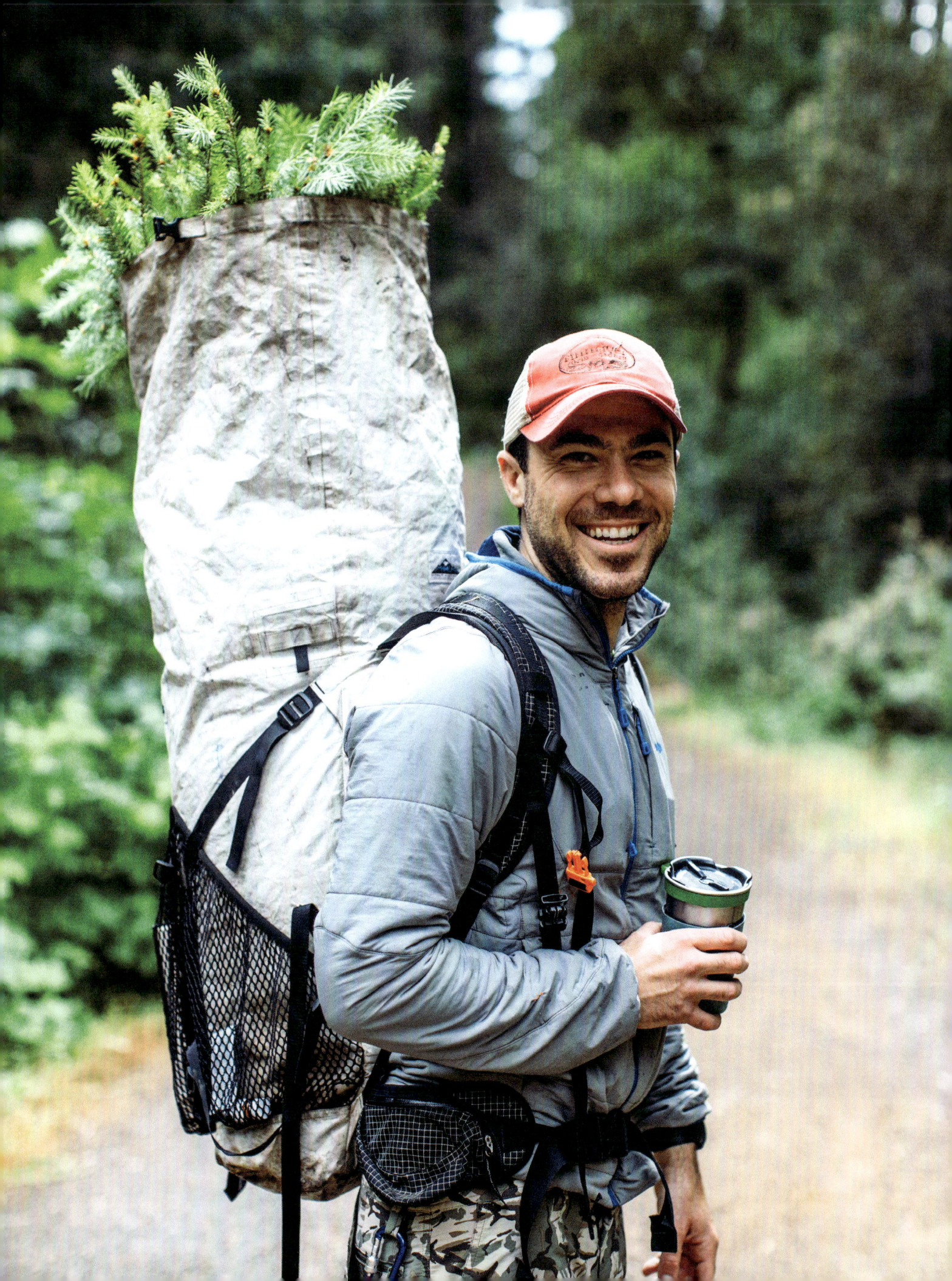

In sustainably harvesting ingredients, landscapes benefit from careful pruning without being harmed in any way.

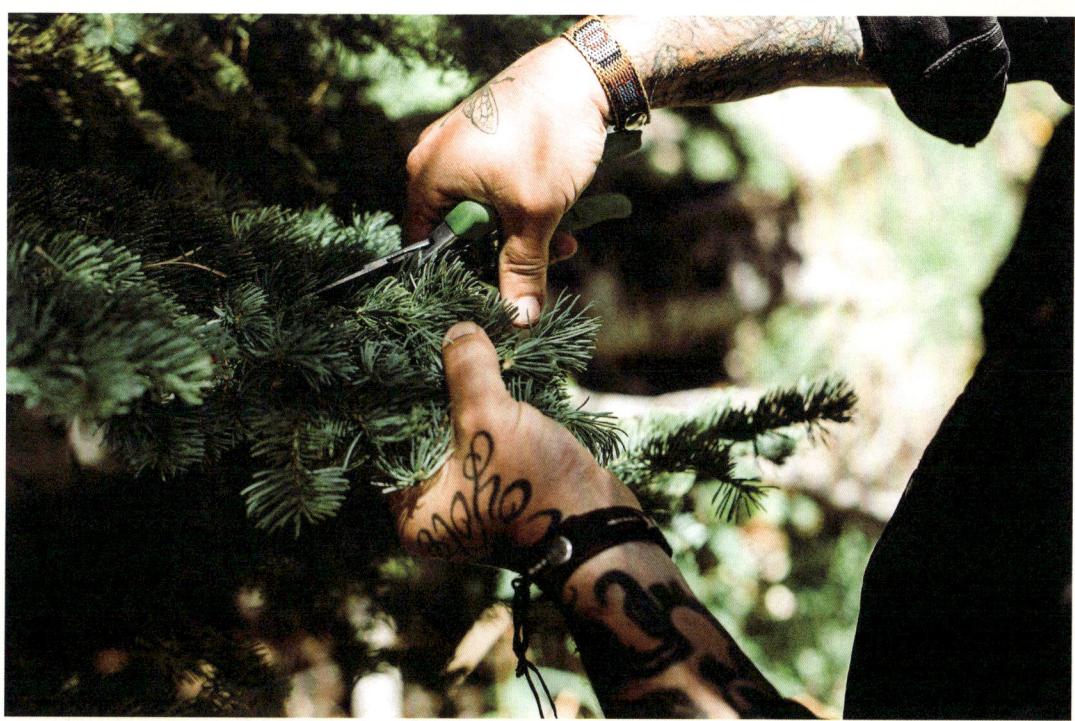

"Most people dream about getting bigger, but I dream about getting smaller, more specific, and weirder."
HALL NEWBEGIN, JUNIPER RIDGE

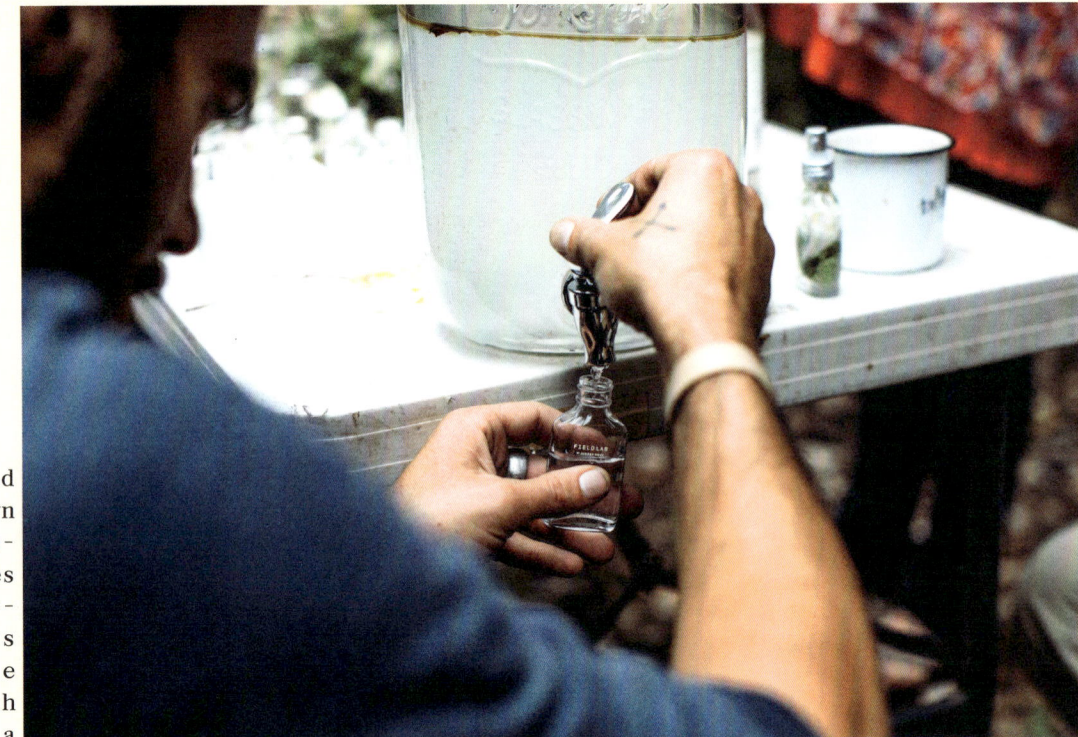

Hall infusing a bottle with the scent and spirit of the wild, with flavors extracted from flowers, moss, dirt, sand, and wood.

Hall has stripped his own life down to the basic elements. He treasures high-quality, artisanal products that are durable and crafted with passion. This is a necessary backlash to "a culture accustomed to plastic, next-day delivery, and instant gratification consumerism." Juniper Ridge products represent the precise opposite, reflecting the "beautiful spirit of the maker movement" that insists on buying less but better. Hall's job title alone, a wilderness perfumer, did not exist before him and it may never do again. "I'm a total freak," he laughs, "so it shouldn't surprise you that my inspirations and heroes are freaks and wanderers, people who aren't afraid to chuck everything away that came before them and try something new."

One interesting sideline for Hall is Desert & Denim, a tradeshow like no other. The idea came to life in an Oakland bar over a number of beers, with three friends (including the founder of Indigofera Jeans) bewailing the state of tradeshows. In the end, someone said: "Let's put on our own thing. Get the best makers in the world together and have campfires under the desert sky. We'll make it beautiful and fun, full of spirit and guts and heart. If we get the best brands in the world together, the stores and buyers and magazines will have to show up. It'll be too good to resist!" The resulting show was a massive success with some of the best brands in the world turning up in a classic "if you build it they will come" event.

While Hall is excited about the success of Juniper Ridge, the near future is unlikely to see a large-scale sell out. "Most people dream about getting bigger," he says, "but I dream about getting smaller, more specific, and weirder. The only way forward for us is to keep digging into beauty." The intention for the company is to continue capturing the spirit of the beautiful places they visit, bottling these moments for the delight of their patrons. By digging deep into the wild places they love, Hall and Juniper Ridge will continue to deliver astonishing snapshots of our beautiful world. ◆

34

GOOD WILL HUNT
BY <u>MADLEN KRIPPENDORF</u>

To some, hunting is a sport, to others a necessity, and for many, a controversial topic. Photographer Madlen Krippendorf was raised in an area where hunting is normal, where tradition and practical necessity blend together to form an important aspect of rural life. It is this rich cultural heritage that informs her work as a photographer. For the hunters she documents, hunting serves multiple functions: as a means of carrying on culture and tradition, as a practical, organic source of food, and as an ecological control to keep populations of wild animals in balance with the environment. Madlen feels there is something important about confronting the source of one's food in its natural state, instead of merely purchasing the branded, neatly packaged offerings from the local supermarket. Precise, neatly framed, and ever-in-tune with the nuances of natural light, Madlen's photographs are a manifestation of her appreciation for the land she calls home and its presence in the lives of people who love it. ◆

"Hearing shots is surprisingly rare. Taking shots without discretion is actually frowned upon by hunters, and every shot is usually a direct hit."

"There will always be conflicting views on hunting and eating meat, but those who have hunted have a clearer and more certain idea of where their food comes from."

PHILIPP SPECHT

(AFTER HIS FIRST HUNTING EXPEDITION)

"There exists an idea of what kind of person
a hunter is, but it's also about the community spirit
and maintaining traditions."

VANCOUVER ISLAND
BY JEREMY KORESKI

THE MOOSE HUNTRESS
BY EVA BROMÉE

There is a conviction amongst some people that all hunting is wrong, often the same people who happily eat supermarket meat with no idea of the supply chain. Eva Bromée challenges our modern connection with nature. She is not seeking out a connection with the wilderness for spiritual or commercial purposes; rather, it is hard-wired into her life as a hunter and hunting guide. There is a genuine sense that her gratitude and humility in the face of nature provides a direct link with a way of life long forgotten in our anthropocentric times. Eva, who is from Klövsjö in Jämtland, lives and hunts in Ammarnäs and Vindelkroken near the Norwegian border and Slipstensjön further to the east. This area of Sweden is an endless silent wilderness, a beautiful land but hard to endure, with brutal winters of near-total darkness. To live and hunt in this terrain is to know oneself. As Eva says, you must be "prepared to sacrifice everything to live for what you love." Earlier humans appreciated the loss of life that goes into every meal involving meat or fish. It was a contract, an energy exchange mindfully done. Gradually, as we have become more separated from our food, this has been lost to the world almost entirely, particularly in modern cities. Eva says this simply: "do not bite the hand that feeds you." Her life in the Swedish wilderness is full of humility and respect, not to mention appreciation for how lucky she is to live so close to nature. Her relationship with nature is one of nurture, of giving to and taking from the wild. ◆

"Eva is not seeking out a connection with the wilderness for spiritual or commercial purposes; rather, it is hard-wired into her life as a hunter and hunting guide."

THE CROOKED FOREST
BY KILIAN SCHÖNBERGER

PALEO FORAGING IN FINLAND
BY OSSI PIISPANEN

In evolutionary terms, 10,000 years is the blink of an eye. It is also about the length of time humans have been eating agricultural products such as milk or grain-based foods; a mere blip in our two-million-year evolutionary history, and something Heikki Ruusunen, a professional forager and leading figure in Finland's paleo diet movement, is quick to point out. Given this narrow timeframe, he believes that our modern bodies are still better adapted to digesting wild plants and whole foods. Photographer Ossi Piispanen spent the summer of 2014 with Heikki, documenting his lifestyle and foraging skills in a series of lush images that paint an expressive portrait of a life lived in close contact with nature. ◆

SURFING THE GREAT BEAR RAINFOREST
BY JEREMY KORESKI

Born and raised in Tofino, British Columbia, a peninsula on the Canadian coast known for its old-growth forests and abundant natural beauty, Jeremy Koreski's work is inextricably tied to the place of his birth. Along with his acclaimed work photographing coastal wildlife and the ins and outs of fly-fishing, Jeremy's images focus on the coastal culture and lifestyle of the people who are fortunate enough to call this incredible place home. A key element of that lifestyle is surfing. One typically thinks of white sand beaches and sunshine, not coastal Canada, when the topic of surfing arises. But Jeremy's work proves that for those with a sense of adventure—and a good wetsuit—mossy rainforests and storm-battered northern coastlines can be equally rewarding places to catch a wave. ◆

NEW FOREST
BY PASSENGER CLOTHING

VANCOUVER ISLAND
BY PASSENGER CLOTHING

THE PASSPORT PROJECT
BY ALEN PALANDER

A FOREST WILDERNESS
BY JÖRG MARX

THE SHEPHERD'S DAUGHTER
BY CLARE BENSON

Clare Benson's images sing with a primal yet familiar tone. They seem to be echoes from a time gone by, when man- and womankind carved lives from the earth with cunning and care. Raw, striking, and hauntingly beautiful, Clare's photography weaves a poetic path through the landscape of her childhood, exploring themes of life, death, time, memory, and mythology. Her work is deeply rooted in her family history, and shaped by a life spent with her father, a former Alaskan hunting guide and archery champion, in the hunting culture of Northern Michigan. The photographs explore the facets of this lifestyle, often using documentary-like styles–though Benson herself has never been hunting. ◆

CUTTING BOARDS FROM NORDIC WOOD
BY SLØJD

At first blush a Sløjd cutting board may appear a fairly straightforward, if beautiful, kitchen implement. But these impressive slabs of Swedish elm are more than a sturdy platform for slicing food. Each board is hand-picked by cabinetmaker Morten Høeg-Larsen from locally sourced Nordic wood; primarily Dutch or Swedish elm that has been felled after succumbing to Dutch elm disease. Morten follows each piece of wood through the entire process, from the lumberyard to his workshop. Upon completion, each board receives the hand-stamped Sløjd logo along with another stamp bearing the geographical location from which the wood was sourced. According to Morten, this geographic stamp not only tells the story of the tree, but also breathes new life into something dead, transforming it into an object fit to live again. ◆

SWITZERLAND BY <u>KEVIN FAINGNAERT</u>

DRAWING INSPIRATION FROM NATURE

OBI KAUFMANN's illustrations and poetry reflect the full spectrum of California's wilderness and is dedicated to its preservation.

Obi Kaufmann is a man of many layers and rhythms, closely responding to his surroundings in the natural world. His love of the Californian wild emerges in a passionate series of paintings, illustrations, maps, and poems. A wilderness advocate, Obi has been walking and painting California for his entire life, the songs of the road emerging through his hands. Under the handle Coyote and Thunder, this is now translating into larger projects such as the forthcoming California Field Atlas. Coyote and Thunder (words that Obi has tattooed on his left hand) is his creative outlet.

When asked whether he feels that nature is magic, Obi responds by saying, "I hesitate at all the clumsy words that try to describe the world of phenomena as a world that is in its nature beyond our power to intuit. Words like magic, divinity, and spirit feel like sloppy language. In my art I express how I believe this world is more beautiful, deep, and profound than I could possibly know and the pursuit thereby is endless and infinitely joyful." This strength of emotion shines brightly in his work through its simplicity and warmth.

Based out of Oakland, California ("the grittiest and most beautiful little city in America," according to Obi), he was born in Hollywood and raised in San Francisco's East Bay. It is California as a whole that moves his heart. "My inspiration was born in all things California, and there it will forever live," Obi says. "I've logged thousands of walking miles across this rolling paradise and can hear its song in every painting, poem, and map that I make."

Over time, he has become a "willing subject to a lifelong parade of massive, heady doses of all the beauty that the Californian wilderness has to offer." Now, he is ready to give it all back. This intention is being woven together in a much bigger project called the California Field Atlas, which will be published by Heyday Books in 2017. In Obi's own words, the project will "transmit this love for the larger story of these ›

"My mission is to compose what is a love letter to the land of gold, oak, condor, and granite."
OBI KAUFMANN

spiraling landscapes, my once and forever home. I am retreading all those steps: hundreds perhaps thousands of foot miles rendered, mapped, and painted." In its totality, this labor of love translates into "a compendium of hundreds of hand-painted maps and trail paintings. My mission is to compose what is a love letter to the land of gold, oak, condor, and granite."

The California Field Atlas is an exhaustive, lyrical ultimate road trip guide. Every inch of the state is detailed and every page drips in soul and color. Like everything Obi does, there is an underlying purpose to uncover an ancient Californian ecology. The project describes his "journey towards understanding California as a single breathing, moving, living system that holds one epic narrative: a thread of natural history bright, poetic, and undeniable." The considered intensity and lyrical flair with which Obi describes his work reminds us how moved he is by the natural world, in a way that many people no longer comprehend.

Obi takes his inspiration from a rich tradition of frontier naturalists, David Douglas to John Muir, Wallace Stegner to Gary Snyder, and finally Joan Didion. "I respond to writers and naturalists who endeavor to see things as they are," Obi says, "and it may be unexpected that I find more inspiration there than I so often do in my fellow painters." Obi draws from a deep wellspring of sources to inform his work, the common thread a zeal for the California he loves so much.

"I find there is a battery inside myself that needs a regular refueling of wilderness and solitude to maintain the me-of-this-world," he says. "I adore cities and all they offer, but give me those mountains! Let them climb over me as much as I climb over them and I will be an easier man on my return. I need the wide open, diverse forests of the Sierra Nevada, empty with light and shining in granite."

Obi's techniques themselves start with his choice of paintbrush: "I get asked a lot what kind of paint I use," he says. "My response is that it is not about

the paint at all, I often use wine, beer, coffee, and lake water. I think about the brush. A quality brush can make smeared dirt look fantastic." There is no doubt that patience drives him to perfect his art. "I am not a religious man. In fact I don't do very much with any discipline at all. I have too much Coyote in me. But I do paint every day. I often work even as I am hiking, trying not to trip." Obi describes his painting as a conversation with himself that never gets tired. But it does not always come easy. He is worried that if he stops, he will forget how. "It is like I am holding a very long rope," he says, "and trying to find the end of it, while holding on to it as a life-line, an anchor." Echoing the fears of artists the world over, he concludes: "The calling is a mixed bag, to be sure."

Obi is passionate about wilderness conservation. As he says: "Save the land, save the habitat, and the wild will hold." He is also excited about the potential for rewilding to restore Californian wildlife: "California, the wilderness state, is the perfect testing ground for this evolving philosophy of how best to maintain the wilderness area we've already protected." ›

> "What we have here is a wholly unique place on this earth, and whatever may come, my fate is gladly bound to it."
> **OBI KAUFMANN**

This love of California permeates everything Obi does: "What we have here is a wholly unique place on this earth, and whatever may come, my fate is gladly bound to it. I will always be a wilderness advocate and will work on adding my voice to the collective struggle for its survival, but I've found the beauty of it all speaks loud enough for itself to crack even the hardest of hearts." Thus his direction is confirmed: through the creativity he is gifted with, Obi Kaufmann will inspire others to recognize the California of his dreams.

The near future will see Obi working with the Human Collective Group in New York City, and with Tuleyome in Northern California on a poetry project on the newly designated Berryessa Snow Mountain National Monument. He is also planning on mapping condors in the mountains behind Santa Barbara, with long-range plans to watch the flowers emerge in spring in the Joshua Tree National Park with the National Park Service.

He has come to view the state of California as a circle. "I see these sprawling landscapes as a single, epic narrative that has invented its own way of being a place at all," he says, "an isolated network that attends to its own sphere with continuing invention regardless of any blueprint that might be given to other, sorrowful places bereft of deserts, mountains, coasts, rivers, glaciers, volcanoes, redwoods, salmon, and condor." Obi himself is also creating his reality, fitting snugly into the wild lands he loves, delighted at never having to stop. ♦

Dusky light pours through branches of subalpine fir, tinting granite hues of flame and coral. Here among the rock and trees, aluminum and nylon spring from the ground, sheltered from the chill wind cutting across the shoulders of the mountain. A nest of twigs and scavenged wood bursts to life, smoke tangling with the sweet mountain air.

Dark brings with it a swirl of stars against a midnight sky, and night sounds too, quiet feet and silent wings.

Solitude calls the brave and the willing to a lonely mountain trail, or deep into a forgotten wood. There is no land untouched by man, but there still exist places where the ghosts of the past linger: whispers from long ago and echoes of those who came before. Places where the wind streaks across the land unencumbered by the constructs of humankind; where raven and bear are kings; where chance encounters test even the strongest of resolves.

Walking barefoot, each step is a conversation with the forest floor. At this pace, the earth blossoms before eyes and toes. Lungs inflate with air — clean and sweet — and relax. Autumnal aspens dance in the breeze; the rustle and shake of their leaves is a gentle rhythm filling quiet spaces. Sunlight filters in, showering the landscape with drops of yellow and sweeping the mind clear. Perhaps that's why the Japanese call it forest bathing.

THE TOWER IN THE FOG
BY NADINE KUNATH

SHORT TRIPS AND LONG WALKS
BY ELIAS CARLSON

For millennia, the natural world has played a dual role in the lives of mankind: friend and foe, sustainer and destroyer. Amassed from a collection of adventures in the Pacific Northwest, Elia's photographs hold these two realities in tension, examining both the power nature wields over mankind and its role as a place of restoration. Set against stunning natural backdrops, the figures in his photos are frequently fragile: at the mercy of their surroundings, yet simultaneously content in their powerlessness.

Elias sees interaction with nature as a fundamental aspect of what it means to be human, and believes that rewards await those who want to explore it: "Throughout my life, nature has functioned as a place of discovery and renewal. And this doesn't require some grand adventure—you just have to be willing to make interacting with nature a priority. Whether it's a day hike, a short road trip, or something bigger, getting out there where the magic happens is the key." ◆

"It's the little things I savor most—a bank of fog rolling over a ridge, or waking up to birdsong."
ELIAS CARLSON

"Nature humbles me: it is vast and I am so small. That contrast is what makes me feel so fully alive."

ELIAS CARLSON

CANADIAN SUMMER
BY <u>EMANUEL SMEDBØL</u>

Emanuel Smedbøl's enchanting images of the mountains and lakes of Western Canada bear all the hallmarks of classic weekend trips and backcountry adventures. Those who have experienced firsthand the magic that permeates the thin air where alpine granite and snowmelt-fed lakes meet the sky are sure to find a familiar yearning stirring within their chests at the sight of his photos. Places like these take hold of one's heart and never let go. For Emanuel, this love was awakened early, during a childhood in a remote mountain valley near the Valhalla Range in Southern Canada. "I feel most alive when I'm out in the woods, seeing a place for the first time. I love the feel of the weather, the smell of early mornings in the mountains, the hills alternately shrouded in fog or baked in sunlight," he says. ◆

"Morning swims are the best way to start the day, the crisp lake air enveloping you. It's incredibly refreshing."

EMANUEL SMEDBØL

"Black rain fell from the sky, and ash floated by like bits of snow. We woke up to an obliterated landscape, the smoke so thick it burned our eyes and scratched our throats."
EMANUEL SMEDBØL

"The raw power of being enveloped
by the wild is what keeps me coming back."
EMANUEL SMEDBØL

MISCELLANEOUS ADVENTURES
BY ANDREW GROVES

Burgeoning by the ubiquity of the internet, small-scale outdoor brands are becoming increasingly common. But not all are created equal. Miscellaneous Adventures, the brainchild of illustrator-turned-woodsman Andrew Groves, offers handmade camping goods for a more discerning consumer. Driven by a concept born on a hike in the Swedish wilderness, this small outdoor brand's mission runs deeper than most. Their core principles revolve around four basic tenets: traditional craft skills, environmental preservation, artistic creativity, and high-quality handmade materials. These principles are used to promote a reconnection with nature during monthly woodland workshops, where participants can pick up traditional skills like wood carving, axe usage, and environmentally sensitive firemaking skills. ◆

A cottage in Ramounat, France, 2012. Ramounat is known as the birthplace of France's back-to-the-land movement.

SCRUBLANDS

BY ANTOINE BRUY

In 2010 Antoine Bruy set out to hitchhike through rural Europe with no predetermined route. He traveled until 2013, driven primarily by chance encounters, but with the purpose of looking at a world largely hidden from the view of modern society. A world composed of individuals who, whether by choice or necessity, have left behind the organized chaos of city life in favor of a self-sufficient lifestyle. A world ruled not by performance metrics and a never-ending cycle of consumption, but by the rhythms and inherent challenges of the natural environment. Antoine's work examines these people and the lives and landscapes they inhabit with a striking intimacy. Each frame resonates with a quiet strength, providing the viewer with an opportunity to reflect on the trajectory of contemporary life. ◆

El Pardal, Sierra de Cazorla, Spain, 2013. El Pardal was established in 1986 and is situated in the Sierras de Cazorla, Segura y Las Villas Natural Park. Here, Antoine Bruy met Amiro, a German man who has been living in the park for the last 25 years, located three hours by foot from the nearest village.

The Workshop, the Pyrenees, France, 2012. "The people I met are able to accomplish so much, with very little." — *Antoine Bruy*

The Pyrenees, France, 2012.
Vincent, taking a break from the
construction of his new house.

Sierra del Hacho, Spain, 2013.
Julian, working on his outdoor
bathtub.

The Pyrenees, France, 2012.
A boy and his puppy in Urs,
a commune in Southern France.

LAST FRONTIER
BY BRICE PORTOLANO

Alaska: home of the grizzly bear and bald eagle, where men still tell tales of rivers so thick with salmon that you could walk across their backs to the opposite bank. For many, Alaska represents the last frontier; one final place left unsullied by the inevitable advance of progress and industry. The state is a vast swath of raw, untamed land that is still largely, and truly, wild. It is here on Prince of Wales Island—the fourth largest island in the United States, and one of the least populated—that Jerry and his wife made their home, earning a modest living by farming oysters from a floating-house with no running water or electricity. Brice Portolano's timeless images capture the full spectrum of a life built deep in the wild landscape, where grit and determination are offset by incredible natural beauty and a deep sense of connection to the land. •

114

CANADIAN CULINARY EXPEDITIONS

Steeped in tradition and with a thriving modern food culture, Newfoundland, Canada, holds a wealth of delicacies. LORI MCCARTHY of COD SOUNDS revives her ancient family heritage to provide intrepid culinary tours.

The people of Newfoundland and Labrador have long sustained themselves from the sea. Their industry was built on the export of salt cod and once nourished people across the globe. Newfoundland's inhabitants ate the leftovers from the haul: the cods' heads, tongues, and sounds. The cod sounds—the air bladders that keep a cod afloat—are today an overlooked gourmet treat, and give their name to an innovative culinary tour company. Cod Sounds, born against the backdrop of the collapsed fishing industry and the region's rich heritage, links both visitors and locals to Newfoundland's timeless landscape, culinary history, and forgotten traditions. Lori McCarthy runs the company from St. John's, the Canadian region's capital and largest city.

For Lori, a big part of her chosen path is the continuation of the culture of Newfoundland. "It's a constant evolution of the traditional and new ways. I think we have to continue to create new traditions in order for our culture to grow and evolve," ›

"It's more than a way of eating, it's our way of life."
LORI MCCARTHY, COD SOUNDS

In a country with long and brutal winters, foraged fruit and vegetables taste all the sweeter. Lori understands the rhythm of the seasons well, bringing the gifts of nature to her delighted clientele.

she says. "What it evolves into is in our hands." You can feel Lori's passion for the place of her birth: "Where I am from has everything to do with what I do. I have a deep connection to this land and its people." Cod Sounds is shaped by Lori's experiences growing up in Newfoundland. "My surroundings, the way I grew up, and my way of life has shaped the person I am today and how I live my life," she says, "from continuing to help farmers make contact with restaurants so they have a market for their vegetables, eggs, and game meat to spending my winters cross referencing new species of wild plants I come across to learn if they are edible."

The company was named after Lori's great-grandfather, Knight. "Great-grandfather always said there was too much fish left on the bones to make away with them," Lori recounts, "so they were removed and salted. The livers were skivered on old clothes hangers and cooked over the open fire. The tongues, cheeks, and heads were all used for frying up for supper and stews. Nothing went to waste." These stories were passed down from Lori's mother, whose own grandmother rose at 4 a.m. each day to "make fish," the expression used for salting fish and setting it out to dry on wooden flakes in the sun. Lori's exploration of these old and new ways of cooking binds her to earlier generations.

The Newfoundland cod fishery collapsed in the early 1990s, yet, as Lori says: "we are a resilient people. As with changing traditions, we have had changing industries." Cod Sounds is a way of showing people what is dear to Lori's own heart. She feels a deep appreciation for "the people that against all odds survived this place, where nothing grows for eight months of the year." She goes on to say that, "We have survived this land of rock and a sea of savagery that is so unforgiving—it takes our lives, our fathers, our sons, and our daughters, yet it gives back with rich fishing grounds that have fed the world."

Hardship is part and parcel of surviving a Newfoundland winter. "I grew up watching my mom bottle and preserve everything she could," Lori says. "In a land where nothing grows for well over half the year, every family preserved, and the pantries of this place are well stocked. Everything from moose, rabbit, seal, bakeapples, and partridge berries. Dandelions are the first green of the year and everyone I knew picked the fresh greens and scalded them down and froze them. They were the first sign of spring and a much-appreciated taste!"

Long before Newfoundland's discovery by European settlers, harvesting, hunting, and gathering were performed there. The heritage that Lori preserves is therefore polycultural. "The ancient cultures of the Port au Choix area and all over Newfoundland, from the Maritime Archaic Indians to ›

In the past, what the land could provide was everything for Newfoundlanders. They endured the harsh climate, reaping the rewards when times were good. Lori restores the vitality of this relationship.

> "Where I am from has everything to do with what I do. I have a deep connection to this land and its people."
> **LORI MCCARTHY, COD SOUNDS**

the Dorset Palaeo-Eskimos, the Beothuk, the Irish, and the English, have all given their part to the traditional food of this province," explains Lori. "While the ground was not and is still not much for farming, the rich fishing grounds, the incredible seal population, the caribou, game birds, sea birds, beaver, and the wild edibles create a pretty incredible food history that has sustained us. These are staples of what enabled us to survive the harsh winters and now we still eat this food because it connects us to the land and the sea, and it is what we have always done. It's more than a way of eating, it's our way of life."

Newfoundland also has a thriving modern food scene dedicated to the taste of place movement, an emerging trend based around local produce, traditional dishes, and fresh, healthy ingredients. Leading lights include Todd Perrin of Mallard Cottage, Shaun Hussey and Michelle Leblanc of Chinched Bistro, Jeremy Charles of Raymonds, and Ken Pittman of Seto, to name just a few chefs and business owners. These people, Lori says, are "committed to developing relationships with farmers, hunters, and fishermen to bring the best products of this place to the plates of their restaurants. They are a very close knit group of passionate people working together to put the food of Newfoundland on the map and are outspoken about the importance of our food and products."

Through Cod Sounds, Lori takes people outside and provides them with a link to traditional food practices. It is incredibly rewarding not only for the visitors, but also for Lori herself. "People say that it's the best part of the excursions," she says. "They say they love how close to the land we live and they feel that connection we have. It reminds me all the time of how special it is here." She notes the incredible depth of forageable fare available—everything from mussels, urchins, limpets, clams, and seaweeds to sorrel, beach lovage, and around 15 to 20 varieties of wild flowers.

This rich variety of ingredients contributes to a Newfoundland tradition called the boil up. Lori describes it with reverence: "It is the most elemental way of preparing food and my personal favorite. You learn how to move the fire to get what you want and stoke it to produce just what you need at the time. Even if I cook nothing, which rarely happens, I can sit and watch it and

keep the wood to it for hours just to watch it burn and sit in a moment." As Lori's mother was a child growing up on the beaches, great stews of cods' heads would feed whole communities: "The stew was cooked up with potatoes and when it was done it was poured out over a big rock and the kids would pick out the pieces of fish with little twigs." Lori herself aims to pass on those special moments to anyone who joins her while she cooks over the fire.

The future is bright for Cod Sounds. Lori is determined to keep these traditions alive and introduce them to whole new generations. "The berry picking, the fishing, the hunting and preserving is just how I live and I will pass it on for as long as I can. My family and the people we surrounded our life with ingrained an appreciation for what we have and who we are, and the older I get the more I love it. I can sit and watch the waves on a beach for hours and marvel at its beauty, I can watch the fog roll in over the hills and even though we lose the sun its beauty is breathtaking. The flat calm of a pond before I throw the first cast and the reflection of the woods in it—how can someone not look at that and love a land that gives us so much?" ◆

THE LAST STAND
BY DAVID ELLINGSEN

How does one grapple with the inherent dissonance between the natural world and a contemporary global culture that, when unchecked, commodifies everything it comes in contact with? David Ellingsen wrestles with this question visually in his series *The Last Stand*. Drawing on five generations of family history in the foresting industry, David's poignant images of old-growth tree stumps—often the remains of trunks that were harvested by his great-grandfather and great-uncle during the heyday of logging—stare back at us like weathered and weary faces from the past. The stumps' presence, and David's treatment of them, is an ominous reminder of both the majesty that once was and the importance of protecting what we still have. •

KANTOORKARAVAAN
BY KANTOORKARAVAAN

Today's technological advances offer tantalizing opportunities for those who want to be close to nature while maintaining a career in the fast paced modern world. KantoorKaravaan is at the cutting edge of these new possibilities with its mobile off the grid office spaces in the Netherlands. These tiny traveling offices set up shop in beautiful wilderness spaces, feature wifi and coffee makers, and, best of all, allow users a chance to work where the air is clean and the birds sing.

THE MUSHROOM CAMPS
BY EIRIK JOHNSON

For a brief two-month season each fall, makeshift shelters spring up haphazardly in the Cascade Mountains in Oregon. The shelters, made of scavenged wood, lengths of twine, and layers of tarpaulin, form temporary homes for hunters of matsutake pine mushrooms. The hunters themselves are diverse—including Southeast Asian families, Mexican migrant workers, and many others—and they gather to forage for the sought-after delicacy, which they sell on for commercial export. For many, this brief window of opportunity will provide their primary source of income for the year. Beginning with these individuals and their makeshift dwellings, Eirik Johnson's series *The Mushroom Camps* artfully traces the trans-Pacific journey of the matsutake to the cavernous processing facilities, auction houses, and street markets of Japan, where the highest-grade mushrooms can fetch upwards of 100 US dollars. ◆

(left) Spring boletes among the pine needles near Sisters, Oregon. (right) A detail shot of mushroom picker Joy and his daughter Belinda with a matsutake, Deschutes National Forest.

(top left) Pickers in a camp near Sisters, Oregon, with a harvest of boletes.
(bottom left) Searching for matsutake among the pine trees, Deschutes National Forest.
(top right) Matsutake buyers set up shop in Stubby's Fuel Stop, Chemult, Oregon.
(bottom right) Mushroom buyer with rare matsutake mushrooms, Chemult, Oregon.

FORAGING AROUND THE CORNISH COAST
BY FAT HEN

In the modern world, where supermarkets and fast food chains offer up a dizzying array of foods unencumbered by season and geography, it is easy to forget the natural cycles that once dictated mankind's diet. With the exception of a few individuals, modern man and woman have lost their connection with the culinary treasures hidden in the forests and fields. Caroline Davey's goal is to reestablish that link. Founded in Cornwall, England, in 2007, Fat Hen is her wild food foraging and cookery school, and a labor of love. The classes she offers serve as a way to reconnect people with each other and the natural environment. Ranging from the seashore to the hedgerow, and from woodland to farmland, Davey's classes promote wellbeing and resourcefulness while providing a tangible relation to our foraging ancestry. ◆

"Foraging alone I feel totally absorbed by the landscape. This is the time when I'm most at ease and in touch with my surroundings."

CAROLINE DAVEY, FAT HEN

FROM THE SEA
For the large majority of seaweeds in Cornwall, foraging is best in spring. For coastal vegetables, it is best to search in spring and summer: spring for sea beet and sea radish and summer for species such as rock and marsh samphire, fennel, and orache.

"I'm blissfully content when picking seaweed on the beach with the roaring waves behind me, breathing in the sea air and sharing the beautiful seascape and horizon with a few gulls."

CAROLINE DAVEY, FAT HEN

"Flowers are always an essential part of my salads—mallow, wild garlic, three-cornered leek, nasturtiums..."

CAROLINE DAVEY, FAT HEN

THE MUSHROOM PICKER
BY BRUNO AUGSBURGER

Each spring, whether it is deep in Canada's Yukon Territory or closer to home in Zurich, Bruno Augsburger ventures out in search of mushrooms. "I search for them everywhere they are: Switzerland, Scotland, Iceland, Canada, Alaska, in the mountains, by the rivers, in the forests. They are often closer than you think," he says. His precisely framed images elicit the joy and thrill of mushroom hunting, that irresistible compulsion to discover the next patch, which any mushroom hunter knows by heart. "Eventually I hope to get to know the whole mushroom universe," Bruno says. "I have piles of books on mushrooms at home. But the ones I know the best are the ones that taste the best. In spring there are the morels, which come in waves. Then porcini in summer, and the chanterelles, birch boletus, and so on." ◆

GIFTS FROM THE SOIL
(Left to right, top to bottom)
The beautiful but toxic
fly agaric mushroom.
Fistfuls of morel mushrooms.
A king boletus emerges from
the earth.
(Facing page, top to bottom)
Unearthing a king boletus.
A boletus laid out to dry.

IN THE EYES OF THE ANIMAL
BY MARSHMALLOW LASER FEAST

Human beings have long been captivated by the abilities of animals. Who has not wished to glide through the forest on the silent wings of the owl, or perform hairpin aerial maneuvers with the precision of the dragonfly? Marshmallow Laser Feast's *In the Eyes of the Animal* aimed to bring a high-tech twist to this age-old fantasy. An immersive digital experience, the 2015 project used lidar (light detection and ranging) scans of trees and detailed CT scans of forest animals, recreating them as high-resolution virtual reality images. These scans were then combined with aerial drone footage, binaural sound design, and tactile stimuli to create a vivid interpretation of the forest from the perspective of its inhabitants. The results were viewed on sculptural headsets in the woods, allowing participants to combine the virtual outdoors with the real. ◆

ESCAPE

BY DANILA TKACHENKO

In every population there exists a solitary few who find the maddening rush of the city and the crushing demands of a life dominated by commerce and economies more than they can bear—the loner, the hermit, the monk. Stories and mythologies of individuals who have forsaken the trappings of civilization and shrugged off social norms for a life of deep solitude in the heart of nature are as old as humankind. Danila Tkachenko's *Escape* series examines the lives of people such as these: some are haunted, driven to escape a past life; others merely find themselves more at peace on their own. All carve quiet niches for themselves from the earth, rock, and wood in places far from where they once called home, while being content to make their way in the world alone. ◆

SUBMISSION
"Man cannot defeat nature. The only thing he can do is submit to it completely. I only understood this after I left."

THE LONG WINTER
"During the first two years it was hard. Once I woke up with frozen fingers, and had to chop them off. Then I got used to it."

152

ALONE
"You think I live here alone? Look at those hills, each has its name, its character. I call them my best friends."

TO KNOW A SPACE
Though blind, this man knows the forest around his dwelling so well that he can orient himself in it perfectly.

THE COMPANION
A wooden god, carved for worship and conversation.

ARTISTIC TOOLS FROM NEW ENGLAND
BY NICK NEDDO

It was the wild corners of Vermont—forest, field, and stream—that first set a spark to the tinder of young Nick Neddo's imagination. He has since carefully tended the resulting flame through his lifelong relationship with the natural world, which is manifested in his artwork and practice of crafting tools with which to create it. Each of these implements and materials is sourced or hand-built by Nick directly from the Vermont landscape, meaning that each finished work is, quite literally, a piece of the land that it originated from. Arranged and photographed, the handmade inks, pigments, paper, pens, and paintbrushes become a work in their own right; a testament to both the abundance of the outdoors and Nick's ingenuity in harnessing it. ◆

SUPPORT THE PARKS
BY PARKS PROJECT

Parks Project takes the concept of giving back to nature and applies a dash of environmentally conscious capitalism. A for-profit business, the project uses the sale of an array of apparel and accessories to connect consumers with conservancies. Each product purchased contributes directly to one of over 20 different conservancies around the U.S., providing vital funding for the ongoing care of national parks. Beyond cutting a check, Parks Project also contributes hundreds of hours of volunteer work in the effort to keep parks pristine. The organization's 10-year goal includes funding 100 projects and generating 100,000 volunteer hours. Their vision is that this crucial work is not only positive for the parks, but also a gateway for reinvigorating relationships with the great outdoors. ◆

WILDERNESS WEEKEND
BY SECRET ADVENTURES

Grand vistas, soaring peaks, and pristine rivers carving their way through picturesque valleys—the scenes that first spring to mind when thoughts turn to a romp in nature. Secret Adventures would like people to think a little closer to home. Madoc Threipland founded the company in 2014 upon returning to London from his overseas expeditions to discover he still had an itch for adventure. The firm curates unusual, off-the-grid wilderness experiences that unite a small group of complete strangers with a seasoned guide for a day or long weekend. The majority of the trips take place in or around London. Offerings such as a full moon swim, fire, and marshmallows sit alongside more exotic options such as wolf tracking in Sweden—proving that adventures large or small can be had, if we are willing to take a chance. ◆

BAGBY HOT SPRINGS
BY AMANDA LEIGH SMITH

THE SPRINGS
Through Amanda's lens, the hot springs brim with a sense of freedom and spontaneity. They are possessed with an ethereal quality recalling shades of folklore, softened by the gentle haze of 35mm film grain.

171

OREGON
Beneath the silver skies of Oregon, nature is both friend and mystery; a place where trees keep watch over all that passes beneath them.

GOOGLE EARTH SERIES
BY STEFAN PETERS

Stefan Peter's *Google Earth Series* is an ongoing collection of landscape paintings created between 2013 and 2016 using photographic landscape images sourced from Google Earth. These images are altered and reinterpreted through Peter's chosen medium of acrylic painting. Atmospheric, at times brooding, and characterized by Stefan's muscular brush strokes, these paintings at first feel familiar, but upon closer inspection reveal oddities such as shadows cast by foreground elements that leave the viewer feeling a little off-balance. Reminiscent of the slightly off-kilter effect of natural history museum dioramas, these paintings also accurately depict the experience of being in nature, where physical energy combines with the imagination to create an experience that is simultaneously foreign and familiar. ◆

176

SUSTAINABLE DECOR
Grain's hand-wrapped mirrors, adorned with twine made from rapidly renewable hemp, are ethically produced with environmental and social responsibility in mind.

BOUND MIRRORS BY <u>GRAIN</u>

OWL STORIES
BY TODD BAXTER

Drawing on themes as diverse as fairytales, taxidermy, classical portraiture, and Native American artwork, Todd Baxter created surreal photographic collages for his series *Owl Stories*. The images, which read like paintings from a world one step removed from reality, are rich in intricate details—many of which are digitally stitched together using elements from different pictures. Todd gathers these elements photographically from national parks, natural history museums, and roadside antique malls, and then weaves them into the final pieces. The resulting narratives are as fascinating as they are disquieting: young people at the mercy of the forces of nature; young people who always seem to be a hairsbreadth away from either safety or doom. ◆

SPACE TRAVELS THROUGH NORWAY
BY OLE MARIUS JØRGENSEN

BOTTLING THE SPIRIT OF THE FOREST

With no prior experience, former publisher CHRISTOPH KELLER has, in a little over a decade, created one of the finest distilleries in the world: STÄHLEMÜHLE.

The Hegau, a beautiful extinct volcanic landscape close to Lake Constance, is the home of Stählemühle. Hidden far down narrow roads is one of the best distilleries in the world, owned and operated by former publisher Christoph Keller. His award-winning liquor (it has received over 200 prizes) blends ancient, artisanal origins with his own wild experimentation. Unlike many distillers, Christoph was not taught his craft by his father or grandfather. He has developed his very own method that incorporates many things that grow nearby, including greengages, zibarte plums, elderberries, and medlar.

When thinking of a distillery, the mind conjures images of a moonshine still in a forest or an industrial-scale factory. Stählemühle is neither, ›

The sun sets on Stählemühle in Germany's Hegau. One gets the sense that wherever Christoph turns his eye, detail and a rigor follow, distilled down to absolute perfection.

"I want to open the eyes of the people to all the wild plants that grow here, and are somewhat forgotten in a culinary sense."
CHRISTOPH KELLER, STÄHLEMÜHLE

instead being the vehicle for one man's ambitious quest to perfect a process. Stählemühle, you quickly realize, has a very different approach than conventional distilleries.

To begin with, Christoph is not interested in growing the business, which he described first and foremost as a farm. His team is small and perfectly suited to their roles. His philosophy is that anything can be distilled and his small-batch liquors reproduce the entire lifecycle of each plant, containing each and every aroma between birth and falling from the tree. "We are using a fermentation process in order to produce alcohol out of botanicals," Christoph explains. "So, the fermentation is some kind of vanitas of the fruit, the rotting, the decline. And this also plays a role when making spirits from fruit. The scent of the blossom, the taste of the fruit can only be experienced through the fermentation process—and in this sense the death of the fruit shines through." Christoph has studied his local environment to an obsessive extent, becoming a mine of knowledge about local plants, fruit trees, and animals.

Escaping to Stählemühle from Frankfurt (he and his wife found the building in a classified ad that mentioned a distilling permit) in 2004, Christoph had never previously distilled anything in his life. However, it was

necessary to retain the permit to produce 300-liters of spirits every 10 years and quickly what started as a hobby became a way of life. Beyond academically learning all he could about distilling before starting Stählemühle, and bringing his design experience to the way the company communicates, Christoph has learned about distilling the best way there is: simply by doing it.

The range that Stählemühle produces is vast, with over 120 types of schnapps with an incredible array of flavors. To complement this, Christoph has planted some 400 fruit trees on the acres around the distillery. However, it is in the wild plants that grow in his surroundings that Christoph's true genius lies, within the mountain ash and medlars, grapes, herbs, and mushrooms. All may be distilled for their flavor. This attention to detail and innovative approach has advanced the art of distilling itself, earning Christoph a medal at Gault Millau, not to mention Destillata's "Distillery of the Year" award.

"Distilling is cooking and condensing, that is it," he says. "But of course, the fine-tuning, the refinement, the finesse, and the knowledge of organic chemistry has grown through the years." Christoph ›

Keller's approach is a blend of simple, ancient distilling techniques and a precise aesthetic born very much in the modern world. His philosophy encompasses much more than the production of alcohol.

recognizes the trade-off of keeping his quantities small and his quality extremely high: "You can control a small quantity of mesh or macerate simply better and be more effective in the fermentation," he says, "which is the crucial point about distilling. Here every mistake leaves its traces, and we just want to be perfect. Less is more when it comes to spirits, and a hand crafted, perfectly fermented and distilled spirit is always better than one that is mass produced." It is a formula that the world responds to well.

Christoph's work is often concerned with finding the best botanicals possible. He estimates 40 percent of his time (he works 12-hour days) is spent speaking to producers, finding rare fruits, and educating people on how to best harvest for distillation. "For me," he says, "the important thing was to open people's eyes to all the other distillates, spirits from herbs, vegetables, mushrooms, nuts, and more." This obsession informs his business, and extends to the precision and perfection of his operation.

Whilst Christoph uses the best ingredients that can be found ("the best mirabelles grow in France, the best Williams pears in South Tyrol, the best apricots in Hungary, and the best oranges in Sicily") he also uses as much of the local flora as possible. "I distill 25 different pears from my region, 12 different grapes, 50 different herbs, etc. This is the local heritage, and I want to open the eyes of the people to all the wild plants that grow here and are somewhat forgotten in a culinary sense," he shares.

Stählemühle immerses both its visitors and everyone who is fortunate enough to sample its products (Christoph barely drinks, by the way!) in a forgotten art closely linked to nature. At the core of what its proprietor does is the natural world surrounding him in the Hegau. "Nature is 100 percent of what we do," he agrees. "All our work circles around nature. We are dependent on the seasons, dependent on the weather, on the fruit, the quality. And also mentally, or for the soul, it is the most important thing." In this way, Christoph aims to connect people with the natural world that they may have forgotten. ♦

THE TASTE OF THE WILDERNESS

Chef MAGNUS NILSSON is the mastermind behind one of the most exclusive restaurants in the world, FÄVIKEN MAGASINET.

Fäviken Magasinet is an utterly unique dining experience located on a 20,000-acre estate in Jämtland, Northern Sweden. Seriously isolated, the restaurant that sits 16 is not an incidental visit, which is a great part of its exclusivity and an important part of the attraction for its many guests. The brainchild of chef Magnus Nilsson, Fäviken is the culmination of long-held dreams (a teenage Nilsson set out a masterplan that would see him running the world's best restaurant, which many believe Fäviken already is).

With a population of just 125,000, the vast area of Jämtland (as well as neighbouring Tröndelag and Kallbygden) provide all of the natural resources used in the restaurant. Fäviken is completely matched to a rhythm traditionally employed by farmers ›

> "I never try to tell people what they are supposed to perceive. I just tell them to come and see us instead."
>
> **MAGNUS NILSSON, FÄVIKEN MAGASINET**

Virtually everything cooked, served, and eaten at Fäviken is born, grown, and dies in the local area. The menu is therefore matched perfectly to the seasons. It is a spectacular achievement for Magnus to continually evolve as a chef.

in the region, the food eaten is entirely seasonal. The bounteous summer and autumn months afford an opportunity to harvest and preserve, storing up materials for the long, cold darkness ahead. What can be gathered, foraged, and harvested from the land is dried, salted, and preserved for the winter. Hunting season brings meat for the restaurant and the stores are filled. Come spring, when they are empty again, the cycle begins anew. Thus Fäviken sustains itself and its visitors.

Hunting season remains a powerful part of Swedish culture, particularly the short period in September when moose hunting season begins. Around 80,000 moose are killed each year, creating a huge amount of meat. For Magnus, this flavor recalls his childhood. He describes the taste as "light, not very gamey, a bit like lean beef." The deep forests that cover much of Jämtland also play host to a rich variety of game, ensuring a diverse menu at all times. Nearby also lie some of the best fishing waters in Europe.

Magnus Nilsson himself grew up hunting and foraging on a 50-acre farm, so it is perhaps little surprise that his vision is so closely bound to the seasons and cycles of the land. "I believe that as a creative person," Magnus says, "everything you have experienced in life, everything you have with you, will create a composite which is whatever it is you create. As spending time in nature was a large part of me growing up in Sweden and still is today, it obviously becomes a big part of what I produce creatively."

Located as far north as Iceland, Northern Sweden is known for the serenity of its forests—a vast and rich silence punctuated only by the movement of the natural world. It is a landscape in which the bright light of home acquires a new warmth and where humans must live alongside nature. Yet despite its geographical remoteness, Jämtland is a teaming hub of gastronomy, with many endemic culinary delights produced by artisans.

The Gulf Stream brings warm air through gaps in the mountains between Sweden and the Norwegian border nearby. This affords the possibility of growing produce more commonly found much further south, though it bears fruition much more slowly. Yet this slow ripening and northern exposure also brings massive advantages in terms of flavor, further enhancing the restaurant's incredible reputation. The ability to source all ingredients from the local area adds a certain pressure to be inventive, resourceful, and to constantly evolve and develop.

After working in Paris for some time, Magnus returned to his home country. He shares that "it didn't feel at all important back then, as I came home by coincidence, ›

"I believe we should be a bit more careful
not to throw away knowledge that seems old to
us right now."

MAGNUS NILSSON, FÄVIKEN MAGASINET

but looking back over the last few years, me coming home to where I belong culturally has been vital." This cultural fit has allowed the chef to weave together his vision, converting the restaurant (housed in an eighteenth century grain store) to serve just 10 people a night. All ingredients are sourced locally (apart from some seafood from Norway) through foraging, fishing, or hunting. Local methods of preparation and preserving (pickling, salting, jellying) guarantee incredible and distinct flavors.

Though this maintains important local customs, Magnus is keen to draw a distinction between what

Fäviken does and clinging onto heritage for the sake of it. "It is important to record and remember any knowledge because you never know when it will be needed again," he says, "but to preserve customs as though in a bubble is a very new and very vain idea which belongs in the mind of modern mankind. Things change and should be allowed to change." Yet there is no doubt that old practices lend their weight to making the restaurant entirely unique. "I believe we should be a bit more careful," Magnus warns, "not to throw away knowledge that seems old to us right now."

If one were told that they would visit one of the most exclusive restaurants in the world, certain assumptions would be made about the decor, the luxury they would be likely to experience. Yet these airs and graces are not part of the Fäviken itinerary. It seems everything is stripped back to let the surroundings and, principally, the food shine through. When asked about a dining experience at his restaurant, though, Magnus does not wish to explain how it feels. "I never try to tell people what they are supposed to perceive, which would really be like telling someone how they should feel," he says, "I just tell them to come and see us instead."

Securing a spot at Fäviken means paying for the food in advance, accepting the terms of the restaurant, with drinks and accommodation paid on the spot. Most diners at the restaurant stay overnight at the ›

A conscious decision to reduce the number of covers, the stripping back of décor to a very particular definition of luxury, and the restaurant's secluded location all assist in awarding it its exclusive reputation.

"Magnus Nilsson himself grew up hunting and foraging on a 50-acre farm, so it is perhaps little surprise that his vision is so closely bound to the seasons and cycles of the land."

location, digesting their food in the serenity of the surroundings. Not much is written about the food, which reportedly must be tasted to be believed. It arrives, apparently, in a whirlwind of dishes, dozens of courses matched to the seasons. Delicacies such as homemade mead to drink, scallops cooked over juniper berries, egg yolk in sugar syrup on a bed of pine tree bark

crumbs—all enhance Fäviken's reputation for unexpected, delicious simplicity.

For Magnus, who went to cooking school in the Swedish ski resort of Åre, it is a return to his roots. Yet to live out there, especially after exposure to the modern city, requires an affinity with solitude. Bringing out patrons to such a remote location forces them into the immediacy of their surroundings—in the absence of distractions it is possible to focus entirely on the food. This approach, so different to the traditional idea of locating a restaurant for maximum footfall, sits well with the history of Jämtland itself. The locality prides itself on being a little different, separate to the rest of Sweden. In the past it was an independent country, its dialect almost a separate language. As a location to manifest Magnus Nilsson's dream, with silence and solitude abundant, it could not be more appropriate. ◆

LIPAN POINT
BY KYLIE TURLEY

YELLOWSTONE NATIONAL PARK
BY LUKE ANTONY GRAM

NORTHEAST, USA
BY BRENDAN LYNCH

Yosemite, the Grand Canyon, Yellowstone: Images of these iconic landscapes are etched into the imaginations of generations of travelers. Brendan Lynch, however, feels it is his duty to promote the less heralded, but no less stunning, landscapes of the Northeastern United States. Brendan's obsession with capturing the transition between seasons in photographs—often taken on solo hikes early in the morning—has resulted in enduring images.

For Brendan, nature is a cathedral: "I find great peace when I'm alone with my camera exploring. I can't stress that point enough. Nature is my religious experience." His dedication to capturing the landscapes he loves in all their glory and subtlety helps make a strong case for adding the mountains of New Hampshire to the aforementioned list of places of great beauty. ◆

"When I woke up the next morning to this beautiful pink, fluffy light, I knew yesterday's weather was payment for today's gorgeous light."
BRENDAN LYNCH

"I love trying to capture the ephemeral moments between two seasons—one season fighting the previous one."

BRENDAN LYNCH

"I hiked 10 miles and gained 6,000 feet, reaching the summit at the crack of dawn. I was up there for two hours taking photos while the clouds wrapped around the mountains."
BRENDAN LYNCH

"This place felt like my temple. I spent four hours alone in these woods walking, sitting, and touching everything."

BRENDAN LYNCH

"At one point I was just gawking and daydreaming in real-time as the clouds turned from pink and orange to the post-sunrise white and blues. My mind was on fire—excited—as I scraped ice from my camera. I felt unworthy."
BRENDAN LYNCH

WILD AT HEART

With a hard-won wisdom way beyond his years, CHRISTIAN WATSON of 1924 is changing the illustration game.

Christian Watson is a young artist who owns and runs an illustration agency called 1924, among many other projects. His prolific output holds a lens to the natural world and displays in perfect flat lay the tools of his trade. The pieces, no matter their size, are loaded with vitality and energy. Christian lives on his craft, resurrecting traditional styles that are based on 1900s advertising processes and doing everything by hand. It renders a precise aesthetic impossible to dismiss as inauthentic.

This uncommon self-taught knowledge has led to working with numerous major clients (Twitter, Puma, Ford) but Christian ›

"I have built tradition into every piece of my work, utilizing the methods used many years before me."

CHRISTIAN WATSON, 1924

"Nature has always had its place in my heart and vision both for what I'm seeing it as, and what potential it has in my work."

CHRISTIAN WATSON, 1924

Using traditional tools and techniques, Christian's tiny illustrations have found an audience all over the world who respond to the incredible detail in the pieces, but also their lighthearted joy.

loves the smaller jobs, too, delivering each with pride and satisfaction. It has not always come so easy. A tough childhood and having to make things work for himself led to great gratitude for what he has each day. Born in Virginia and raised in Oregon, Christian studied architecture in Boston and (when he is not on the road) lives in Texas.

The obvious success Christian has experienced, standing out in a hyper-competitive field as an illustrator, does not sit too easily with him. He is obsessed with telling a story about who he is and why he is. To him, success is humility and honesty, kindness, and not caring what other people think. His personal goal is to impact one person at a time, making them laugh or cry, moving people in monumental ways. This is his very personal quest.

The way Christian describes his work is compelling. It is "old method branding" and his brand 1924 is "reclaimed and handcraft," it has been "forged, found, and curated in the Pacific Northwest." The word purist comes to mind and this extends to his choice of tools, avoiding the use of convenient digital assistance and relying only on tools such as lead, paper, paint, and canvases. This DIY ethic, wrought through natural flair and countless hours of dedication, shines through in the authenticity of the work. People like it, plain and simple.

The kid can write too. "I wonder if the dust still danced above in a room I can't see," he wrote in an extract from a journal kept during his *Forth Goes the Road* project, "and if grandma was yelling at God or the Devil." There is a gravity to what Christian chooses to let out. "In order to change," he says from a hilltop in Austria, "older parts must be shed or become noticeably different. Like a moth to the flame, growth changes all of us. All sorts of growth in life and the constant is its inevitability. I write this with heavy eyes." Wherever he turns his hand, it seems, absorbing output flourishes. ›

"Stories start and end just like a life, so as much as I can equate it, I'm more or less just a part of what I'm a part of while I'm here."
CHRISTIAN WATSON, 1924

> "Build your house above the clouds even if sometimes ya gotta get your butt back to reality."
> **CHRISTIAN WATSON, 1924**

Christian's body itself tells a story. The tattoo count: "Currently, a solid 44," he laughs. "All of the pieces are relative to my heritage of family being involved tightly in the US Navy for a number of years. Each line is hand drawn by myself and then converted by a few select tattoo artists around the States." This heritage extends into his work: "I have built tradition into every piece of my work, utilizing the methods used many years before me, though not necessarily among my own family. The idea of hard work was more assuredly passed down by my father, his father, and his father, too. Nothing good comes easy."

Christian's work usually has a natural element, which he cites as a great inspiration for his illustrations. His travels encompass mountain wilderness from Switzerland to Alaska. However, in terms of his photographic work (he defines himself as a "film-photography-fanatic") nature is "the only thing that gets my attention on a continuous basis," he says. "Nature has always had its place in my heart and vision both for what I'm seeing it as, and what potential it has in my work."

Christian's outlook is firmly based on not seeing things as more permanent than they truly are: "As far as I know, all of us are living in a story, all of us are that main character on the train, looking out the window and figuring it out as we go. Stories start and end just like life, so as much as I can equate it, I'm more or less just a part of what I'm a part of while I'm here."

For a deadly serious artist, there is a lot of humor and lightness in his work. Each piece is a reminder not to take things so much to heart. "Even I fail at that," he laughs. Beyond the ocean and the mountains, in the human realm his inspirations include Ryan Muirhead, Jedidiah Jenkins, and Fernando Pessoa. ›

GET OUT.
GET GOIN'
GET LOST.
GO.

"Stay a mouse or get killed walking
with the confidence of a cat."

CHRISTIAN WATSON, 1924

If you strip away all the hype and attention, at heart Christian is an incredibly talented illustrator taking pride in his work. It is a values-based industry in which quality need never be sacrificed for quantity.

Christian runs the 1924 ship (now involving three integral employees, Gavin, Clint, and Michael) but also a creative outlet called US CO, a place for creatives to come together, share, try, fail, and succeed. Each piece is crafted with a purpose and a story, making a strong connection between product and maker.

Christian's own process with the micro illustration work is painstaking. "Patience is definitely the main virtue," he says. "If you try to rush it there is absolutely no correcting the mistake, they may have made nibs finally small enough to translate ink, but there is no quick fix, especially of proportional value. I also think that you have to be okay with where mistakes lead you, but that's with any sort of creative work, I've found. I think I feel better when a micro illustration is finished, I wouldn't say it's more satisfying, it just feels better to end. All in all, they are some of my favorite pieces to do because I am always proud of them." Often, within his work, there are messages to himself on how to deal with certain situations. "It can seem a little brazen," he says, "but that's because I'm more agitated with myself and it's like 'HEY, KID, FIGURE IT OUT' more than trying to preach any sort of message."

The near future for Christian will see him working on a project called *Forth Goes the Road*. In his own words, it is very simple: "a boy drives to Alaska in a car that's old and unreliable, with a film camera or two, and no cellphone, no access to maps, motels, hotels, or comforts, and then documents the journey." This is what the future holds and he could not sound more excited: "I head out in September of 2016, and plan to be gone for 30 days, but we'll see how long I take, how far I get." ◆

"A boy drives to Alaska in a car that's old and unreliable,
with a film camera or two, and no cellphone."

CHRISTIAN WATSON, 1924

OUT THERE
BY BRUNO AUGSBURGER

Bruno Augsburger's photography verges on poetry. Lyrical yet precise, awash in the silver northern light of the Canadian Yukon Territory, he wields his camera like a paintbrush in the hands of a skilled painter. Through his lens, this rugged landscape comes to life in all its remote splendor. Over the last fifteen years, Bruno has been embroiled in a love affair with the Yukon. He ventures out alone for weeks at a time, relying on traditional bushcraft skills to survive, returning with tales of the northland: bush planes and eagle feathers, brooding landscapes, and moments of serenity. Of his time alone, Bruno says, "It is the most pure, magical environment you can envision, but also the most threatening. It makes you realize how vulnerable you are. Everything feels more intense in the bush." ◆

"Bush planes are a bit like taxis, but if the weather is bad you have to wait for days."
BRUNO AUGSBURGER

"Being this far out changes your whole sense of being. No roads, no cell phone reception, no nothing except for the land with its own laws."
BRUNO AUGSBURGER

"I feel the need to explore places physically, to become one with my environment. I love to sleep under open skies."

BRUNO AUGSBURGER

236

237

> "I appreciate little things like a cup of coffee, a warm fire, or a dry tent. Things you take for granted back home."
> **BRUNO AUGSBRUGER**

VANCOUVER ISLAND BY EMANUEL SMEDBØL

SZŐDLIGET
BY VIKTOR EGYED

FISHING HUTS
The small lakeside fishing town of Szödliget, Hungary, has its own unique atmosphere. It is just as dreamlike as it appears. An idyllic place for people who want to escape for a while.

THE RETURN
After stumbling on the village by accident, Viktor vowed to return when the weather was more cooperative in order to fully capture the magic of the place.

THE SOUND OF WIND
BY JENNY RIFFLE

LAST FRONTIER
BY BRICE PORTOLANO

Index A–F

ALEN PALANDER
Canada
www.alenpalander.com
» pp. 64–67
LOCATION: Vancouver, Canada

AMANDA LEIGH SMITH
United States
www.aleighsmith.com
» pp. 170–173
LOCATION: Bagby Hot Springs, OR, United States
ADDITIONAL CREDITS: Styling: Tashina Hill; Editorial for Volcom x Stay Wild Magazine

ANDREW GROVES
United Kingdom
www.miscellaneousadventures.co.uk
» pp. 104–105

ANTOINE BRUY
France
www.antoinebruy.com
» pp. 106–111

BRENDAN LYNCH
United States
www.youseethenew.com
» pp. 204–213

BRICE PORTOLANO
France
www.briceportolano.com
» pp. 112–119, 250–251

BRUNO AUGSBURGER
Switzerland
www.brunoaugsburger.com
» pp. 142–145, 230–239

CHARLES POST
United States
www.charlespost.com
» Front endpaper
LOCATION: Denali National Park, AK, United States

CHRISTIAN WATSON/1924
United States
www.1924.us
» pp. 214–229, opposite title and imprint page

CHRISTOPH KELLER/ STÄHLEMÜHLE
Germany
www.staehlemuehle.de
» pp. 186–191
PHOTOGRAPHY: Lea Meienberg (p. 186 top), Christoph Keller (pp. 186 bottom, 187, 188 bottom), Jochen Hirschfeld (pp. 188 top, 189, 190–191)

CLARE BENSON
United States
www.clarebenson.com
» pp. 70–71

CORNELIA KONRADS
Germany
www.cokonrads.de
» pp. 16–19
PHOTOGRAPHY: Cornelia Konrads, VG Bild-Kunst, Bonn 2016
LOCATION: Percorso ArteNatura di Arte Sella, Borgo Valsugana, Italy (pp. 16–17); Skulpturenlandschaft Osnabrück, Germany (pp. 18–19)

DANILA TKACHENKO
Russia
www.danilatkachenko.com
» pp. 148–159

DAVID ELLINGSEN
Canada
www.davidellingsen.com
» pp. 126–129

EIRIK JOHNSON
United States
www.eirikjohnson.com
» pp. 132–135
PHOTOGRAPHY: Eirik Johnson, courtesy of the G. Gibson Gallery, www.ggibsongallery.com

ELIAS CARLSON
United States
www.eliascarlson.com
» pp. 92–97

EMANUEL SMEDBØL
Canada
www.fieldandforest.co
» pp. 98–103, 240–241
LOCATION: Vancouver Island, Canada (pp. 240–241)

EVA BROMÉE
Sweden
www.luonddus.se
» pp. 46–49
PHOTOGRAPHY: Erik Olson/ Lundhags (pp. 46, 47 top, 48–49) www.lundhags.se, courtesy of Eva Bromée (p. 47 bottom)

FAT HEN
United Kingdom
www.fathen.org
» pp. 136–141
PHOTOGRAPHY: Myles New (pp. 136, 138 bottom, 141 top), Tom Young (p. 137), James Bowden (pp. 138 top, 140, 141 bottom), Stefan Amato (p. 139) www.pannier.cc

Wildside

FÄVIKEN MAGASINET/
MAGNUS NILSSON
Sweden
www.favikenmagasinet.se
» pp. 192-199
PHOTOGRAPHY: Courtesy of
Fäviken Magasinet (pp. 193,
198-199), stills from a film
by Mr Jacopo Maria Cinti
for MR PORTER; Director of
Photography: Erik Nordlund;
Producer: Marie Belmoh
(pp. 192, 194-197)

GRAIN
United States
www.graindesign.com
» pp. 178-179
PHOTOGRAPHY: Ben Blood

ISAIAH RYAN AND
TAYLOR CATHERINE
United States
www.theryansphoto.com
» pp. 8-15

JANNE SAVÓN
Finland
www.jannesavon.com
» pp. 20-21
LOCATION: Wytham Woods,
United Kingdom

JENNY RIFFLE
United States
www.jennyriffle.com
» pp. 248-249
LOCATION: Snoqualmie,
WA, United States

JEREMY KORESKI
Canada
www.jeremykoreski.com
» pp. 44-45, 58-59
LOCATION: Vancouver Island,
Canada (pp. 44-45)

JÖRG MARX
Germany
www.joerg-marx.de
» pp. 68-69
LOCATION: The Bavarian
Forest, Germany

JUNIPER RIDGE
United States
www.juniperridge.com
» pp. 26-35
PHOTOGRAPHY: Skyler Greene
for Candy Mountain Collective
(pp. 26, 27-29, 30 bottom,
33 bottom, 34 bottom, 252)
candymountaincollective.com,
Colin McCarthy (pp. 30 top,
31) www.colin-mccarthy.com,
Monica Semergiu (pp. 32, 33
top, 34 top, 35)
www.monicasemergiu.com

KANTOORKARAVAAN
Netherlands
www.kantoorkaravaan.nl
» pp. 130-131

KEVIN FAINGNAERT
Belgium
www.kevinfaingnaert.com
» pp. 74-75
LOCATION: Matterhorn,
Switzerland (p. 74),
Zermatt, Switzerland (p. 75)

KILIAN SCHÖNBERGER
Germany
www.kilianschoenberger.de
» pp. 50-51
LOCATION: Gryfino, Poland

KYLIE TURLEY
United States
www.kyliefly.com
» pp. 4-7, 200-201
LOCATION: Lipan Point, Grand
Canyon National Park, AZ,
United States (pp. 200-201)

LORI MCCARTHY/
COD SOUNDS
Canada
www.codsounds.ca
» pp. 120-125

PHOTOGRAPHY: Scott MacLeod (p.
120), Lori McCarthy (p. 121),
Newfoundland and Labrador
Tourism (pp. 122-123, 124),
Ken Holden (p. 125)

LUKE ANTONY GRAM
Canada
www.lukegram.com
» pp. 202-203
LOCATION: Yellowstone National
Park, WY, United States

MADLEN KRIPPENDORF
Germany
www.krippendorf.photo
» pp. 36-43

MARSHMALLOW LASER
FEAST
United Kingdom
marshmallowlaserfeast.com
» pp. 146-147
PHOTOGRAPHY: Luca Marziale/MLF
ADDITIONAL CREDITS:
Concept and Direction: Robin
McNicholas & Barney Steel,
Visual Artist: Ersinhan
Ersin, Visual Artist: Natan
Sinigaglia, vvvv Artist:
Abraham Manzanares, Designer:
Marc Winklhofer, Sound Design:
Antoine Bertin, Producer:
Eleanor (Nell) Whitley,
Assistant Producer: Annatruus

Index G–Z

Bakker, MLF Executive Producer: Adam Doherty. Commissioned by Abandon Normal Devices and Forestry Commission England's Forest Art Works. Produced by Abandon Normal Devices and Marshmallow Laser Feast. Supported using public funding by Arts Council England and Forestry Commission England. Equipment supported by Nvidia and Sub Pac.

NADINE KUNATH
Germany
www.nadinekunath.de
» pp. 88–91
LOCATION: Saxon Switzerland, Germany

NICK NEDDO
United States
www.nickneddo.com
» pp. 160–163
PHOTOGRAPHY: Susan Teare
ADDITIONAL CREDITS:
Originally published in: The Organic Artist, Quarry Books, 2015

OBI KAUFMANN
United States
www.coyoteandthunder.com
» pp. 76–87
PHOTOGRAPHY: Heidi Zumbrun (p. 77), Colin McCarthy (p. 79), Obi Kaufmann (p. 80)
ADDITIONAL CREDITS:
Illustrations: Obi Kaufmann, Texts: Elias Carlson (pp. 82–87)

OLE MARIUS JØRGENSEN
Norway
olemariusphotography.com
» pp. 184–185
LOCATION: Hemsedal, Norway
ADDITIONAL CREDITS:
Model: Kristian Valen-Sendstad

OSSI PIISPANEN
Finland
www.piispanenossi.com
» pp. 52–57

PARKER FITZGERALD, JAMES FITZGERALD
United States
www.ransomltd.com
» pp. 22–25
ADDITIONAL CREDITS:
Styling: Amy Merrick, Model: Skye Velten; originally published in: Kinfolk Vol. 5, 2012

PARKS PROJECT
United States
www.parksproject.us
» pp. 164–167
PHOTOGRAPHY: Allie Dominguez (pp. 164–165), Alex Schwarz (p. 166 top), Hana Ardelean (pp. 166 bottom, 167 bottom), KC Brown (p. 167 top)

PASSENGER CLOTHING
United Kingdom
www.passenger-clothing.com
» pp. 60–63
PHOTOGRAPHY: David Wren (pp. 60–61), Mackenzie Duncan (pp. 62–63)
LOCATION: New Forest, Hampshire, United Kingdom (pp. 60–61), Vancouver Island, Canada (pp. 62–63)

SECRET ADVENTURES
United Kingdom
www.secretadventures.org
» pp. 168–169
PHOTOGRAPHY: Jocelyn Low (p. 168), Ed Stone (p. 169)

SLØJD
Sweden
www.slojd.org
» pp. 72–73
PHOTOGRAPHY: Monica Bach

STEFAN PETERS
Belgium
www.stefanpeters.be
» pp. 174–177

TODD BAXTER
United States
www.baxterphoto.com
» pp. 180–183

VIKTOR EGYED
Slovakia
www.behance.net/EViktor
» pp. 242–247
LOCATION: Sződliget, Hungary

ZUTTO
Russia
www.flickr.com/orange_zutto
» Back endpaper
LOCATION: Lake Turgoyak, South Ural, Russia

WILDSIDE
THE ENCHANTED LIFE OF HUNTERS AND GATHERERS

This book was conceived, edited, and designed by GESTALTEN.

Edited by ROBERT KLANTEN and SVEN EHMANN

Preface by LAUREN NAPIER
Project texts and texts for illustrations (pp. 82–87) by ELIAS CARLSON
Features and one project text (pp. 46–49) by DANIEL CROCKETT

Editorial Management by LINA GÖTTSCH
Text edited by AMY VISRAM, NOELIA HOBEIKA, and VICTORIA PEASE
Proofreading by BEN BARLOW

Creative direction of design by LUDWIG WENDT
Layout and Design by JEANNINE MOSER
Typefaces: ARCHIVE by THE ENTENTE;
ATLAS TYPEWRITER by KAI BERNAU and SUSANA CARVALHO;
and CALIGO by ARON JANCSO (Gestalten Fonts)

Cover photography and lettering by CHRISTIAN WATSON
Back cover photography by CHARLES POST (left);
CHRISTIAN WATSON (top right);
and COURTESY OF FÄVIKEN MAGASINET (bottom right)

Printed by Nino Druck GmbH / Neustadt/Weinstr.
Made in Germany

Published by Gestalten, Berlin 2016
ISBN 978-3-89955-672-8

© Die Gestalten Verlag GmbH & Co. KG, Berlin 2016

All rights reserved. No part of this publication may be reproduced or transmitted in any form or by any means, electronic or mechanical, including photocopy or any -storage and retrieval system, without permission in writing from the publisher.

Respect copyrights, encourage creativity!

For more information, please visit www.gestalten.com.

Bibliographic information published by the Deutsche Nationalbibliothek. The Deutsche Nationalbibliothek lists this publication in the Deutsche Nationalbibliografie; detailed bibliographic data are available online at http://dnb.d-nb.de.

This book was printed on paper certified according to the standard of FSC®.

FSC MIX Paper from responsible sources FSC® C006655